COLUMBIA
SOUTH CAROLINA
· A HISTORY ·

ALEXIA JONES HELSLEY

THE
History
PRESS

Published by The History Press
Charleston, SC 29403
www.historypress.net

Top front cover image courtesy of Photos by David, www.flickr.com.

First published 2015

Manufactured in the United States

ISBN 978.1.62619.815.9

Library of Congress Control Number: 2014959299

*For Terry, Cassandra, Johnny, Keiser, Justus, Jacob and Sarah Beth,
as well as Columbia—a great place to live and rear a family.*

"Home is where the heart is."

CONTENTS

ACKNOWLEDGEMENTS

The author gratefully acknowledges the assistance of Chad Rhoad and Katie Parry of The History Press; Steve Tuttle, Patrick McCawley, Marion Chandler and Brian Collars of the South Carolina Department of Archives and History; Debbie Bloom, Walker Family Local History Center manager, Richland Library; Herb Hartsook, director of South Carolina Political Collections, Hollings Special Collections Library, University of South Carolina; Beth Bilderback, visual materials archivist, South Caroliniana Library, University of South Carolina; and Michael Wukela, strategic policy advisor, Office of Mayor Steve Benjamin, City of Columbia. And as always, she especially appreciates the support of her family and the contributions of Terry Helsley, indexer and photographer.

Looking toward Gervais Street Bridge, Riverfront Park, 2014. Waterways have a long and distinguished role in Columbia's rich history. *Photograph by Terry L. Helsley.*

"Columbia, a Capital City"

C olumbia, a city in search of an identity, is the second capital of the state
of South Carolina. It owes its status and eminence to ancient geologic
events and accidents of geography—or, as realtors like to preach, "location,
location, location." Located in the geographic center of the state, Columbia
has long struggled in the shadows of, first, Charleston, the colony's and
state's first capital, and, second, the throbbing economic energy of the urban
upstate cities of Greenville and Spartanburg.

Nevertheless, after several centuries, walking thorny paths and navigating
dangerous shoals, Columbia has now claimed its place as South Carolina's
"first" city—a destination, not a pass-through place. Standing tall in
the Midlands, Columbia in the twenty-first century is a bridge between
lowcountry and upstate, melding old and new dreams and possibilities. Its
story has the strength of river rapids and the breadth of a river at flood stage.

ANCIENT COASTLINE

And now it deepens, slow and grand
It swells as, rolling to the land
An ocean broke upon thy Strand,
Carolina!

—"Carolina," by Henry Timrod

Columbia lies on an inland peninsula between the Congaree and Wateree Rivers in a unique geologic region known as the fall zone. In South Carolina, the term "fall zone" denotes the boundary between the piedmont foothills of the Appalachian Mountains and the Atlantic Coastal Plain. The fall zone, which stretches from Alabama to New Jersey, also marks the boundary between metamorphic and sedimentary rock. Thus, the fall zone is the ancient coastline of the Atlantic Ocean during the Mesozoic Era. Specifically, during the Cretaceous Period of the Mesozoic Era, approximately 100 million years ago, higher ocean levels produced sand hills and kaolin deposits—such as those that underlie the city of Columbia. These ancient unconnected hilly remnants of prehistoric dunes striding across South Carolina physically mark the boundary between the upcountry and lowcountry.

Historically, the fall zone also marked the terminus of inland river travel, as the change in rock formations often produced rapids and waterfalls that made river travel difficult above the fall zone. At the fall line, travelers and traders had to unload their cargoes and continue on foot. Later, the

falls and rapids of the fall zone furnished power for gristmills, sawmills and other manufacturing in South Carolina. Consequently, this geologic formation interrupted travel on South Carolina's inland rivers. Similarly, the fall zone rapids on the Congaree River interrupted river traffic to the Broad and Saluda Rivers. Traders and travelers, by necessity, paused and regrouped. This geologic interruption, then, was a factor in the eventual location of South Carolina's new capital. For example, the Congaree River was navigable below Granby—a natural dividing line between the upper coastal plain and the piedmont.

Perhaps equally important was the social and economic significance of this geologic and geographic break. Until the 1730s, most of the Europeans and Africans who immigrated into South Carolina arrived through the port of Charles Town. But beginning in the 1740s with families such as the Hamptons, they began arriving in the Carolina Piedmont from Virginia, Pennsylvania, Maryland and other colonies to the north. These intrepid pioneers traveled down the Great Wagon Road or Warrior Path seeking new lands. The carnage and uncertainty of the French and Indian War exacerbated this southern migration of primarily Scots Irish settlers and their families. Consequently, by the 1760s, this influx was filling in the Carolina Piedmont and redefining the backcountry of South Carolina—for example, the modern counties of Lancaster, York and Chester, whose names belie the Pennsylvania roots of their first European residents.

Initially, these incomers were farmers who cleared fields, planted crops and raised livestock. Many were Presbyterians who valued worship and education. They wanted churches, schools and safe environments for their families. Yet their desire for settled communities and village amenities faced serious obstacles. In the colony of South Carolina, the capital of Charles Town was supreme. The elegant city on the peninsula between the Ashley and Cooper Rivers was the seat of government, justice and recordkeeping. To record deeds, probate wills, pay taxes and file civil and criminal legal complaints, upcountry settlers had to travel long, arduous, dangerous miles by foot, by horseback and, perhaps, at times, by water to reach Charles Town. As Søren Kierkegaard noted, "Justice deferred is justice denied." For upcountry residents, the distance challenged their quest for order and stability and, in time, provoked local action.

In addition to its distance from the capital, the backcountry was also a dangerous place. Following the end of the French and Indian War (the Treaty of Paris officially ended the conflict in 1763), multiracial gangs plagued the isolated settlements of the upcountry. Displaced and dispossessed by war, the

bandits burned crops, houses and barns. The outlaws also rustled cattle and stole other livestock. They pillaged homes and property, tortured or killed the inhabitants and raped women. Travelers were not safe on the roads. Brigands took not only goods but also lives. Not even doctors on errands of mercy were safe. In frontier settlements, the criminals flaunted their lawlessness and proffered stolen goods for sale, and some merchants found it easier to accommodate the lawbreakers than to resist them.

In 1766, a naïve new South Carolina governor disastrously undermined the tenuous connection between upcountry and lowcountry. Backcountry residents had, after many disappointments and much effort, successfully apprehended several men suspected of nefarious crimes. As required by law, they transported the accused to Charles Town. There, the accused were tried, and six were found guilty. Unfortunately for the peace of the backcountry and sectional relations, Lord Charles Greville Montagu, the newly arrived royal governor, pardoned five of the accused in a vain attempt to bolster local support for his administration. Montagu served as governor of the colony from 1766 to 1773. His administration not only exacerbated sectional conflicts but also contributed to South Carolina's quest for independence.

Given the lack of governmental support, in the summer of 1767 the upcountry men resolved to take matters into their own hands. While outlaw gangs acted without regard to law or common decency, the outraged citizens organized companies for local defense. These vigilante companies whipped miscreants and attacked outlaw hideouts. The bandits responded in kind, and civil war erupted in the upstate. By October, the different local groups had united and exerted a coordinated attack. Known as the Regulators, these vigilantes drove the outlaws and rustlers from the South Carolina upcountry. They restored order for those seeking law-abiding communities. The Regulators were hardworking, upwardly mobile farmers and small planters whose goal was to bring law and justice to the upstate. Although the total number of participants is not known, hundreds of men were involved. In 1767, the Regulators submitted a list of their concerns to government officials in Charles Town. They demanded courts and jails.

In time, the South Carolina General Assembly addressed upcountry concerns, authorized ranger companies and, in 1769, passed the Circuit Court Act. This legislation established four circuit court districts. Each of the new districts had a courthouse and a jail. In addition, there were sheriffs and justices who would sit on circuit hearing cases in the various courthouses. Although the records continued to be kept in Charles Town, the Circuit Court Act intended to bring local and speedier justice to backcountry settlers.

Initially disallowed in England, the Commons House of Assembly revised the act, and eventually, it was approved. By 1772, with the storm clouds of independence gathering, the new courts were functioning.[1]

CLASH OF CULTURES

Remote from any white people...

—*John Lawson*

At the time of English settlement, the Congarees—a Native American group—lived near the site of modern Columbia, although not necessarily within the current bounds of Richland County. By the time the English traveled to the interior, these possibly Siouan speakers were few in number. Decimated by disease (the legacy of early Spanish explorers such as Hernando de Soto), the Congarees lived in "straggly" villages possibly on the banks of the Congaree Creek and cultivated the "three sisters"—corn, beans and squash. When John Lawson, an adventurous young Englishman, visited in 1701, he found the Congarees hospitable and the Congaree women pretty and fond of games. At least as early as 1682, a delegation of Congarees, Waxhaws and Esaws visited an Ashley River Plantation in search of trade.

Unfortunately, for their survival, the Congarees had to face not only European disease but also the consequences of political alliances. During the deadly Yemassee War, the Congarees sided with the Creeks against the South Carolinians. In the fall of 1716, Congaree and Santee warriors attacked outlying English plantations. Nevertheless, that winter, the Carolina militia ended the Indian threat. It captured many of the rebellious Indians and sold them into slavery. With the aid of the Cherokee nation, the South Carolina colonists eliminated the threat and signed peace treaties with the Creeks and

other Indian groups. As a result, in an effort to distance themselves from the settlers, the Congarees moved farther inland and eventually merged with the Catawba nation near the North Carolina/South Carolina boundary. Prior to the Yemassee War, the Catawbas had been allies of the English—valued for the prowess of their warriors. Their disaffection was short-lived. During the winter of 1716–17, the Catawbas not only made peace with the government in Charles Town but also offered sanctuary to the beleaguered Santee and Congaree refugees. Consequently, the Catawba nation maintained its status and grew in power and population.[2] Later, the Catawbas supported Carolina Patriots against the British during the American Revolution.

After the English settlement of Charles Towne in 1670, the new colonists quickly sought economic opportunities in the new land. Some raised cattle and wheat, and others speculated in land. But one of the best early routes to wealth was the lucrative Indian trade. Traders with loaded packhorses left Charles Towne and followed a well-worn path inland to the Midlands. The Cherokee Path extended from Charles Towne to "Congarees," where Congaree Creek intersected with the Congaree River. At the Congarees, the path branched. One path led northward to the Catawba nation, while the main fork ran northeasterly to the Lower Towns of the Cherokees. At Ninety Six, a branch of the Cherokee route ran southwesterly toward Fort Moore and Savanna Town on the Savannah River—gateway to the valuable Creek trade. Fort Moore, constructed in 1716 after the Yemassee War, lay roughly seventy miles west of the spot where the Congaree River broke through the sand hills of the fall zone.[3] The colony expected Fort Moore to deter attacks, especially by French or Spanish Indian allies. Until the founding of Augusta across the Savannah, the fort also controlled access to Indian trade markets in Georgia. The Carolina traders carried iron implements, blankets, beads and other manufactured goods that they exchanged primarily for deerskins.

In 1718, to protect this important trade nexus, the colony of South Carolina established Fort Congaree, the first English outpost in the fall zone. Captain Charles Russell commanded the new fort, which was more of a stockade (or factory) for trade goods than a military outpost. The fort stood on the west bank of a bend in Congaree Creek below Cayce. Despite its origins and trading role, the first Fort Congaree had a short life span.

Later, in 1748, the council authorized an officer and twenty men, with assistance from the inhabitants, to construct another fort closer to Congaree Creek. The new fort, finished by May 31, 1749, was a larger, better-defended facility. This fort had palisades, four bastions for cannons, barracks to house a permanent military detachment and possibly a moat. By the 1750s, the fort

was also a place of refuge for settlers in times of civil unrest or Indian attacks.[4] Yet, with the end of the French and Indian War, this fort also fell into disuse. In 2014, archaeological excavations located the site of Fort Congaree II in the Riverland Park subdivision. According to State Archaeologist Jonathan Leader, excavators identified the site of one of the fort's four bastions.[5]

In 1732, after the new colony transitioned from Proprietary to royal control, the new royal governor, Robert Johnson (who was, incidentally, the last Proprietary governor as well), proposed a "scheme" to settle the backcountry. At the time, the colony faced internal and external challenges. Externally, Charles Town and environs occupied a small strip of land in the South Carolina lowcountry. Settled lands stretched about twenty-six miles inland. The colony, therefore, was vulnerable to Indian attacks (such as during the Yemassee War), as well as raids from the Spaniards and their allies in Florida. Internally, by 1720, the majority of South Carolina's population was black. Consequently, slave owners were uneasy, and some feared a slave uprising.

In an effort to address both issues—protection and population equalization—Governor Johnson asked the Board of Trade in England to approve a series of townships. Laid out across the middle of the colony, geographically, the new townships would act as buffers to protect the lowcountry settlements from Indian, French and Spanish threats. Population-wise, the colony planned to recruit Protestant emigrants from Europe to settle and farm the frontier townships. As incentive, the colony offered eligible emigrants who were willing to undertake the challenge free land, agricultural implements, seeds and livestock. British officials approved the proposal, and consequently, surveyors laid out a series of townships stretching from Purrysburg on the Savannah River (the first of the new townships) to Kingston Township on the Waccamaw River.

In 1733, Johnson ordered a new township laid out in the Midlands at the Congarees. The boundaries of this township ran from Sandy Run on the Congaree River to beyond Twelve Mile Creek on the Saluda River. The seat ("town") for the new township lay near the site of the old Congarees fort. Germans and German-speaking Swiss settled Saxe Gotha Township, once known as Congaree Township. By 1760, there was a town also called Saxe Gotha on the west bank of the Congaree River downstream from modern Columbia. At that time, the township had a population of 850.[6]

FRIDAY'S FERRY

Hoof beats of a lone horse disturbed the sleepy calm of Friday's Ferry. A weak and dazed Mary Cloud clung to the horse's mane and moaned as she slipped to the ground. Bloodied and disheveled, Cloud told a horrific tale of betrayal and death. Four days earlier, a party of Savanna Indians visited the Clouds' remote homestead. With gracious frontier hospitality, the Clouds entertained the visitors. They dined together, and the Indians sat up late smoking pipes of tobacco with her husband, Isaac. Late in the evening, the visitors bedded down on the hearth, and the Clouds climbed up to the loft to bed.

In the morning at cockcrow, the visitors attacked the Cloud family—killing Isaac, the children and the hired man and gravely wounding Mary. For three days, she lay helpless among her dead, until one of their horses wandered back. Tomahawked above the knee and under her right arm, the wounded woman struggled aboard the horse and made her way to the nearest settlement—Friday's Ferry on the Congaree River. The colonists there rallied to her aid, and the South Carolina Commons House of Assembly funded her care. Unfortunately, Mary Cloud did not survive her ordeal. She died from her injuries and was buried in Charleston. Friday's Ferry flourished into the 1780s. And when the legislature laid out the new capital, the site for the new city lay across the Congaree River from the ferry.

Located in the fall zone, the roots of Friday's Ferry lay in the distant past. During the Proprietary years, an important Indian settlement stood on Congaree Creek. In 1719, the colony established its first inland trading post nearby on the Congaree River. The new outpost was an important relay point for north and south commerce and transportation. Later, in 1748/1749, the colony added a fort—Congaree Fort—to protect trade in the area from Iroquois depredations. According to Larry Ivers, regular soldiers from one of the independent companies garrisoned the fort.[7]

In 1754, the dashing Lieutenant Peter Mercier commanded the garrison. Mercier led his men to assist George Washington in building a fort on the Ohio. The colony of Virginia had requested assistance from the other colonies. The Virginians planned an expedition to counter French efforts to expand their control and sphere of influence in the Ohio River Valley. During the ensuing Battle of Great Meadows between French forces and their Indian allies and the colonial troops, the thrice-wounded Mercier died bravely in battle. The Battle of Great Meadows sparked the deadly colonial conflict known as the French and Indian War.

Mercier was the second husband of Elizabeth Haig. Her first husband, George Haig, surveyed Saxe Gotha Township, served as an Indian agent for the governor of South Carolina and operated an Indian trading post. In 1748, while on a trading expedition to the Catawba nation, Seneca Indians kidnapped Haig. One year later, Haig died in captivity.[8]

On May 11, 1754, the South Carolina General Assembly established a ferry on the Congaree River under the control of Martin Fridag (Friday), a Swiss immigrant. Friday's Ferry in Saxe Gotha Township connected Granby on the west side of the river with a smaller settlement on the east side and, eventually, with the new city of Columbia. The act establishing the ferry vested it in Friday and his heirs for seven years. The act also set fees for passage on the ferry: one shilling and three pence per person, five shillings for an empty cart, ten shillings for a loaded cart, seven shillings and six pence for an empty wagon, twenty shillings for a loaded wagon and six pence per head for livestock.[9]

Friday purchased land near the site from Patrick Brown. Later, the area was known as Granby, and in 1765, two Camden merchants established a trading post there. During the American Revolution, the British occupied Fort Granby, and both sides used it as a staging area for military operations. Following the Revolution, Granby became the seat for the new district of Lexington. In 1791, President George Washington recorded favorable comments about the town, and in 1802, John Drayton described Granby as a thriving town larger and more populous than the new state capital across the river. But while Columbia grew, Granby declined, and in 1820, Lexington became the seat for Lexington County.

During the American Revolution, the strategic importance of the Midlands produced conflict. For example, on May 1, 1781, Lieutenant Colonel Henry Hampton with several companies of light dragoons and other troops surprised a Loyalist contingent that was guarding Friday's Ferry near Fort Granby. Major Andrew Maxwell led the Grenadier Company of the Prince of Wales American Regiment. In fact, Hampton attacked two groups of Loyalist and British troops, killing at least eighteen in what is known as a Patriot victory. So, although there are no known skirmishes or battles in Richland County, according to Terry W. Lipscomb, "the river sea bluff south of present-day Columbia was an important encampment site and staging area for patriot forces."[10]

Commissioners laid out the new town on a high plateau near where the Broad and Saluda Rivers meet to form the Congaree River. The site sits on a line of sand hills girding the state and enjoys a mild climate

with adequate rainfall and little snow. The site is not only the geographic center but also, according to John Montgomery, a "center of geographic diversity" surrounded by red clay to the north and rich bottomlands to the south.[11]

CAROLINA CYNOSURE

We have here a great variety of peaches & apples & my vineyard abounds…
—*Benjamin Waring*

In 1785, the General Assembly enacted legislation organizing the state into districts—officially, South Carolina now had local government. As a result, the South Carolina upcountry had increased, but not equalized, legislative representation. Discussion then began about the financial and governmental advantages of creating a new capital for the state of South Carolina. Upstate residents wanted a more centrally located capital. They resented the long, difficult trip to Charleston in order to transact business. Among those who argued for a new site was Brigadier General Thomas Sumter, the Gamecock hero of the American Revolution. Sumter so favored a more central location that he laid out a new town in 1783, Stateburg, his vision of a new state capital near his home in the high hills of the Santee.

Nevertheless, it was 1785 before the General Assembly passed a resolution creating a committee to "investigate the feasibility of locating the seat of government at a central part of the state." Legislative leadership of the South Carolina House of Representatives referred the resolution to the Committee on Grievances. The chair of the committee was General Charles Cotesworth Pinckney of Charleston. Pinckney, who favored the status quo—that is, keeping the capital in Charleston—refused to submit a report.

As a consequence, the House forwarded a suggestion to the South Carolina Senate that, in the future, the South Carolina General Assembly

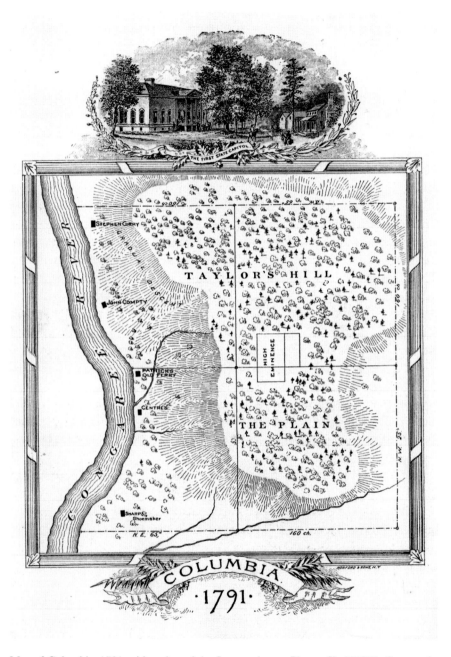

Map of Columbia, 1791, with a view of the first statehouse. Picture file 900051. *Courtesy of South Carolina Department of Archives and History.*

"should" meet "in the most central and convenient part of the State." The ploy worked, and in March, the Committee on Grievances filed a report recommending Camden as the new capital. This suggestion failed by a vote of sixty-eight to fifty-four. Another possibility was William Thomson's Belleville Plantation near the Wateree and now in Calhoun County, but Patrick Calhoun and Henry Pendleton suggested Taylor's Hill.

At this juncture, State Senator John Lewis Gervais, who represented Ninety-Six District, moved that the capital be laid out at the city's current location—on the east side of the Congaree River. Gervais (who died in 1798) was a prominent South Carolinians of Huguenot descent who had also served on the South Carolina Council of Safety during the early years of the American Revolution and in the Continental Congress (1782 and 1783). Consequently, the General Assembly enacted legislation to elect commissioners to lay out the new capital. The site of the new capital lay by the Congaree River near Friday's Ferry and included 650 acres owned by Thomas Taylor and his brother, James. The Taylor plantations were known as the Plains and Taylor's Hill.

The commissioners were Alexander Gillon (a naval hero of the American Revolution) of Charleston, Judge Henry Pendleton of Saxe Gotha, General Richard Winn of Winnsboro, Colonel Richard Hampton of Saxe Gotha and Colonel Thomas Taylor of Taylor's Hill. The commissioners purchased land not only from the Taylor brothers but also from a total of ten local landowners.

The commissioners laid out the new city on a grid two miles square. They divided the grid into blocks with broad streets and also reserved four acres for the use of state government. The new planned city had streets at least 60 feet wide, and the boundary streets and main crosstown arteries were 150 feet wide. The northern boundary for the new city was Elmwood Avenue, and the southern boundary was Heyward Street. Harden Street was the western boundary, and the Congaree River was the eastern boundary. The city's streets bore carefully selected names. The north–south streets west of Assembly were named for heroes of the American Revolution, such as General Benjamin Lincoln, Continental army commander who surrendered Charlestown to the British in 1780, and General Horatio Gates, the hero of Saratoga whom many consider to be responsible for the American defeat at Camden in 1780. East of Assembly Street, the north–south streets honored the names of South Carolina militia generals, such as Thomas Sumter (the Gamecock) and Francis Marion (the Swamp Fox). The streets that ran east–west were named for prominent South Carolinians such as John Lewis Gervais, who was instrumental in the creation of Columbia as the new capital.[12]

Funds from the sale of the lots were expected to pay the costs of building a statehouse and a residence for the governor. As part of the transaction, the Taylor brothers each received two acres of land in the new town. During construction, Thomas Taylor oversaw affairs in Columbia, but state business continued to be conducted in Charleston. In September 1786, officials first offered Columbia lots for sale in Charleston.

In 1787, John Gabriel Guignard laid out the new city. Reverend Isaac Smith conducted the first religious service in the new town, at the home of Colonel Thomas Taylor. By April 1788, construction was underway for about fifty houses in Columbia.

BRIDGING THE CONGAREE

Prior to the laying out of the city, Richard and Wade Hampton acquired Friday's Ferry. On March 25, 1785, the legislature granted them license to operate the ferry for fourteen years. At times, strong winds and currents made travel on the ferry difficult. As a result, in 1791, the general assembly approved Wade Hampton's request to build a bridge across the river. With the expected visit of President George Washington, city leaders anticipated that the bridge would be ready before his arrival. Regrettably, flooding destroyed the almost completed bridge, and in 1792, the legislature granted an extension. But that bridge failed as well. In fact, in 1796, a major flood once again destroyed the third bridge. A similar attempt to bridge the Broad River also failed.

Eventually, the first Gervais Street Bridge over the Congaree River finally opened on April 4, 1827. And in 1829, a bridge also opened across the Broad River.[13] In 1799, the legislature authorized a new ferry over the Congaree River at the foot of Senate Street.[14] The new capital, located in the center of the state, was a natural hub for trade and travel. Upstate traders brought furs, livestock, corn and other agricultural produce that were exchanged for such lowcountry commodities as salt and manufactured goods.

During the Constitutional Convention of 1790, disgruntled Charleston delegates launched a last-ditch effort to move the capital back to Charleston. The effort failed, and the new constitution specified that the new city of Columbia was the official capital and seat of government for the sovereign state of South Carolina.

COLUMBIA: THE NAME

The new capital owed its name, "Columbia," to John Lewis Gervais. In a derogatory manner, Arnoldus Vanderhorst criticized the remoteness of the site. He contended that as the site lay outside the bounds of law and order, it would be a place of refuge and sanctuary for the lawless. Gervais responded to such comments that the new capital would be a sanctuary under "the wings of Columbia."

By the time of the American Revolution, "Columbia" was also an accepted alternative name for America. Also, in 1776, noted African American poet Phillis Wheatley first used Columbia as the personification of liberty. Wheatley, who died in 1784, was the first African American writer published in the United States. By 1801, the district surrounding the new United States capital had become known as the District of Columbia. Later, in 1843, the song "Columbia, the Gem of the Ocean" appeared. In addition to South Carolina's capital city, at least nineteen other cities are also named Columbia. The arrival of the Statue of Liberty eventually displaced this earlier personification of America. Yet according to John Montgomery, South Carolina's capital was the first city in the new country to bear the name Columbia.

THE NEW CAPITAL

On May 29, 1789, commissioners sent a progress report to Governor Charles Pinckney noting that "James Brown the Carpenter had given us satisfactory reasons why the State house is not finished according to his contract" but added that the building would be ready within two months and necessary work completed "for the reception of the Legislature and for placing of the public records which will be finished by the first day of December next." Also, the commissioners reported that "the house of the Honorable Thomas Taylor is well calculated and ready for a Government House." In addition, when the first session opened, Columbia would have accommodations for 217 persons and livery service for seventy-two horses, with overflow accommodations for 109 persons and seventy-two horses in Granby. Commissioners Thomas Taylor, Richard Winn, Alexander Gillon and Richard Hampton signed the report. The new capital was ready for business. The state's records reached their new home in 1789, and in 1790, the Constitutional Convention convened in the newly completed statehouse.

South Carolina's first statehouse sat on a hill overlooking the Congaree River. The site included one city block—bounded by Gervais, Senate, Assembly and Main (then Richardson Street). Possibly designed by James Hoban, the new statehouse was ready for occupancy by the end of 1789.

Program for the 1891 Centennial Celebration, commemorating the first meeting of the General Assembly of the state of South Carolina in Columbia in 1791. Picture file 900051. *Courtesy of South Carolina Department of Archives and History.*

The wooden structure faced Main Street. At that time, both Senate and Main Streets were open through what is now the capitol complex.[15]

On January 4, 1791, the first legislative session convened in Columbia. At that time, the city was still unfinished. Frame structures lined the unpaved streets, and much of the site was still undeveloped. While the legislature was in session, state representatives, senators and other government officials vied for available rooms in the boardinghouses and hotels—each of which eagerly touted its advantages. Prior to this first legislative session, state officials had moved their records and offices to the new capital. The new capital, according to Governor John Drayton, stood on a "beautiful eminence" and could be seen for miles. By 1802, Columbia had between eighty and one hundred houses and, unless the legislature was in session, was a quiet place. Yet "the arrival of loaded waggons from the upper country" disturbed Columbia's tranquility. To aid business, Columbia had an oil mill and a ropewalk.[16] In his *Statistics of South Carolina*, published in 1820, Robert Mills noted that the statehouse was "a temporary building of wood, neat in its general appearance and commodious."[17]

The new city, a planned city, grew—albeit slowly. In 1792, the population of Columbia included 2,479 white residents and 1,451 black residents. As André Michaux noted, "The legislature…meet there annually on the first of December and all the business is transacted in the same month; it then dissolves, and, except at that time, the town derives no particular advantage from being the seat of government."[18]

THE PRESIDENT COMES CALLING

The year 1791 was one of excitement. In May, President George Washington visited Columbia as part of his southern tour. The president traveled in a specially built carriage with appropriate aides and staff. On May 21, while Washington was staying in Augusta, Georgia, three Columbia residents—Colonel Thomas Taylor, Colonel Wade Hampton and Robert Lythgow—arrived with Archibald Jamieson, a Granby businessman, to escort the president to Columbia. In the early morning of the twenty-second, the party left Augusta and reached Granby by sunset. Along the way, Richard Winn, a Revolutionary soldier, and men from Granby and Winnsboro joined the presidential party. From Washington's perspective, the "road from Augusta to Columbia" wound its way through a poor, hilly "pine barren."

At that time, the road passed through old Saxe Gotha, renamed Granby prior to the American Revolution, and crossed the Congaree at the old Friday's Ferry, then operated by Wade and Richard Hampton. At Granby, they boarded a ferry that carried the party across the Congaree River to Columbia. According to Washington's diary, he crossed the river on a flat-bottom boat "at a Rope ferry." Crowds lined the riverbank, eagerly awaiting the president's arrival. On the Columbia side, mounted men met the president, and Captain Kershaw's light horse troop arrived, saluted the president with great dignity and then accompanied Washington to a reception in the city. In his diary, Washington second-guessed the commissioners—he thought that the city should have been placed below the falls of the river rather than on Taylor's Hill.

At noon on Monday, May 23, 1791, residents from Columbia and surrounding areas—such as Granby, Winnsboro, Camden, Stateburg, Belleville and Orangeburg—attended a presidential reception. After the reception, the president and his entourage proceeded to the House

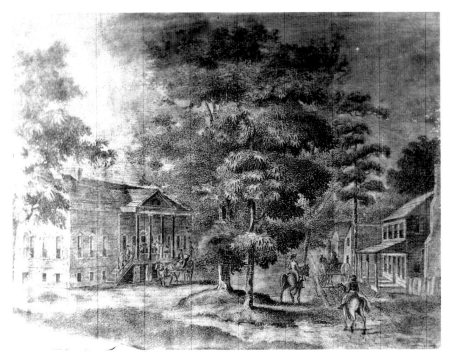

Columbia's first statehouse, 1794. In 1791, President George Washington toured Columbia and dined in the "commodious" wood-frame statehouse. Picture file 900051. *Courtesy of South Carolina Department of Archives and History.*

of Representatives for a 4:00 p.m. public dinner. There, the president encountered and was introduced to sixty-seven women.

Then, the party, including 153 leading men, primarily from Columbia, walked to the Senate chamber for an ample "farmer's dinner" and sixteen after-dinner toasts. The group first toasted "the United States." In response, President Washington then toasted "the State of South Carolina." The group toasted the French assembly, the United States Congress, the Constitution and the Revolutionary army, as well as General Nathanael Greene, who was instrumental in driving the British out of South Carolina; Judge Henry Pendleton, who was one of the commissioners appointed to lay out Columbia; and the quick establishment of a national capital. In addition, some of the toasts had a modern ring. For example, one toast prayed, "May our mild laws, and the happy administration of them, render America an asylum for the oppressed." Others called for more exports and fewer imports and "an increase of well-established seminaries of learning."

Due to an injured horse, Washington spent an extra day in Columbia. As his extended stay was unanticipated, there were no planned public functions. So, Washington dined privately. On Wednesday, the president and his entourage departed Columbia en route to Camden. A delegation from Columbia attended his departure.[19]

Despite the president's concerns, his visit to Columbia was a success. Residents fondly remembered the visit, and when Washington died, Columbia mourned. In January 1800, residents gathered at the home of Major Joshua Benson to plan a "last tribute of respect." As a result of this meeting, the assembled group appointed Colonel Thomas Taylor to chair the committee and named R.H. Waring secretary. Committee members were J.G. Guignard, Dr. William Montgomery and Reverend Mr. D.E. Dunlap.

The committee recommended a special day of commemoration and mourning: February 3, 1800. In addition, it suggested that Dunlap, a Presbyterian minister, deliver the address. Also, the men proposed that all public business "be suspended," that residents wear mourning on their left arms for thirty days and that residents convene at Benson's house and march in procession from there to the statehouse.[20]

Edward Hooker, a Yale graduate and tutor at South Carolina College who spent several years in Columbia, regularly entered his impressions in his diary. From his description, written in 1805, the new statehouse had two stories, and several state officials—including the treasurer, secretary of state and surveyor general—had offices on the first floor. Hooker, in a rather jaundiced manner, noted that there were "other rooms," which from

Hooker's perspective were "used for little else than lodging rooms for the goats that run loose about the streets." So, from Hooker's notes, it appears that Columbia was a quiet place where livestock roamed freely. On the positive side, he noted the beautiful Pride of India trees that lined Main (Richardson) Street and the "lofty forest oaks" around the statehouse that gave "the scenery a rural and a charming cast."

In the beginning, the new capital lacked several essential amenities. Specifically, the residents did not have a public cemetery. Consequently, in 1797, the state legislature designated a city block for that purpose. Today, First Presbyterian Church and its cemetery occupy that block.

Becoming the county seat of Richland District in 1799 was a much-needed boost to the local economy. As a result, in time, Columbia had a handsome courthouse and a county jail. In 1800, Jesse Arthur began construction of the new jail. By 1801, the jail was open for business. The act that designated Columbia as the county seat also named the following

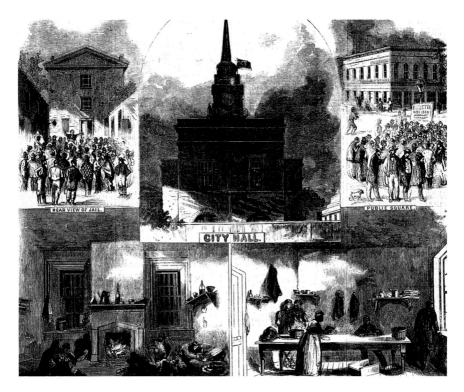

Columbia City Hall, with jail, public square and officers' quarters. Incorporated in 1805, the city of Columbia operated a city hall and a jail. Picture file 900051. *Courtesy of South Carolina Department of Archives and History.*

as commissioners to build and repair the courthouse and jail: John G. Guignard, John Hopkins, Timothy Rives, John Goodwyn and John Taylor. Jesse Arthur built the two-story brick jail. As county seat, Columbia attracted more year-round residents and, consequently, more businesses.

Yet the main event that produced economic prosperity for Columbia was Eli Whitney's new invention, the cotton gin. The cotton gin dramatically changed the face of South Carolina. Suddenly, short-staple cotton was economically viable. Cotton production was no longer confined to the lowcountry's Sea Island long-staple cotton. As a result, piedmont and upstate farmers rushed to cultivate the new crop and embraced plantation slavery to enhance production. With the coming of cotton to the Midlands, Columbia prospered as a market for cotton producers. Initially, cotton traveled by land or by boat below the fall line. But with the construction of the Columbia Canal, cotton and other crops moved more easily to Charleston and overseas markets.

The General Assembly's efforts toward easing sectional tensions between backcountry and lowcountry continued in the early 1800s. In addition to creating the new capital, the legislature established a new college, elected the state's first upstate governor (James Burchill Richardson) and, in 1808, passed legislation addressing representational inequities.

According to the *Columbia Telescope*, in 1816, Columbia had one thousand residents and 250 houses. By 1812, the residents had four churches: the Presbyterians organized a church (First Presbyterian

Governor James Burchill Richardson (1770–1836). Born in St. Mark's Parish on December 8, 1802, Richardson became the first upstate resident to serve as governor of South Carolina. In addition, Richardson served in the South Carolina General Assembly and was also a member of a prominent political family—six members of which served state governors. Picture file 900051. *Courtesy of South Carolina Department of Archives and History.*

Church) in 1795 and called David E. Dunlap as pastor, the Methodists organized a church in 1803, the Baptists organized a church in 1809 and the Episcopalians organized a church on 1812. Once the congregations organized and grew, most moved to erect sanctuaries. For example, the Baptists built their first building in 1811. Later, in 1826, the Catholics organized St. Peter's Catholic Church.

BECOMING A CAPITAL

[T]his is a very healthy place: it is high, dry & sandy…
 —Thomas Cooper

In 1805, the South Carolina General Assembly incorporated Columbia. Also, by 1805, the new county seat had a jail and courthouse. These much-needed institutions addressed residents' needs. Nevertheless, throughout much of the antebellum years, Richland County grand juries routinely presented concerns about security and upkeep of the jail. Those convicted of capital crimes were hanged (after 1868, in the jail yard). Columbia residents recalled public executions. For example, J.F. Williams, as a child, watched a triple hanging in Columbia. Later, in 1912, executions were moved to the state penitentiary and the electric chair.

In 1818, Columbia's first city hall opened. The building on Main Street also housed on the ground floor Columbia's public market. Butchers offered freshly cut meats, and farmers peddled their produce. By 1860, the vendors and the market were moving to Assembly Street. In addition to produce grown in the area, the Columbia market attracted purveyors and drovers from Eastern Tennessee and Western North Carolina. In season, the market offered a smorgasbord of apples, peaches, watermelon, squash, tomatoes, beans, corn and other produce. Assembly Street offered more space for vendors. The market successfully expanded and survived until it relocated to Bluff Road in 1951. Ancillary businesses—such as boardinghouses, hotels, restaurants and bordellos—

Farmers' market, Assembly Street, Columbia, 1950. Columbia's first farmers' market operated from the street level of the city hall on Main Street. But by 1860, the market vendors were moving to Assembly Street, and in 1951, the market moved from downtown to Bluff Road. South Carolina Department of Transportation, S233002. *Courtesy of South Carolina Department of Archives and History.*

grew up around the market. The market was also near the railroad depots on Gervais Street.

But for the city's growth to continue and for the capital to claim its position as a major urban center, Columbia needed improved education and transportation options. Columbia quickly established itself as an educational center.

EDUCATION

The years between Columbia's founding and the outbreak of the Civil War were times of great educational achievement in Columbia. In 1792, the General Assembly authorized the Columbia Female Academy. Incorporated in 1795, a self-perpetuating board operated the academy. The first trustees for the school were James G. Hunt, James and Thomas Taylor, George Wade and Benjamin

Waring. Under the leadership of Abram Blanding, in 1798, the school opened for students. Between the years 1820 and 1883, the academy occupied space at the corner of Washington and Marion Streets in Columbia.

Later, there were other educational opportunities for Columbia's young women. In 1817, for example, residents opened the Female Academy, with Dr. Elias Marks as the first principal. Marks served the school for eleven years before opening another institution. In 1826, Dr. Marks founded the South Carolina Female Collegiate Institute at nearby Barhamville. Normally, 164 students attended the institute annually. Students studied history, literature, art, foreign languages and music and were encouraged to exercise. Barhamville students were an elite group and included a daughter of John C. Calhoun; Ann Pamela Cuningham, who saved Mount Vernon; and Martha Bulloch, the mother of President Theodore Roosevelt.

South Carolina College/ University of South Carolina

The year 1801 was an especially important one for the state's future. That year, the General Assembly established South Carolina College. The state appropriated $50,000 for construction and $6,000 to cover faculty and staff salaries and other expenses. The new institution opened in 1805. Rutledge College was the first building on the historic University of South Carolina (USC) Horseshoe. Other significant early buildings included the South Caroliniana Library (circa 1840), considered the oldest separate college library building in the United States; Harper College (circa 1848), used by Federal forces as a prison; and Legare College (circa 1848), site of the 1865 extra legislative session.

On April 28, 1805, the trustees selected Jonathan Maxcy (1768–1820) as the college's first president. Maxcy, a native of Massachusetts, was a well-known scholar, orator and Baptist minister. He served as the second president of Brown University and the third president of Union College before becoming the first president of South Carolina College. Maxcy also published a "Discourse Designed to Explain the Doctrine of Atonement." Robert Mills designed an obelisk honoring Maxcy. Dedicated in 1827, the obelisk stands in the historic Horseshoe.

The legislators envisioned the new college not only as an educational alternative to New England or European colleges but also as a meeting place

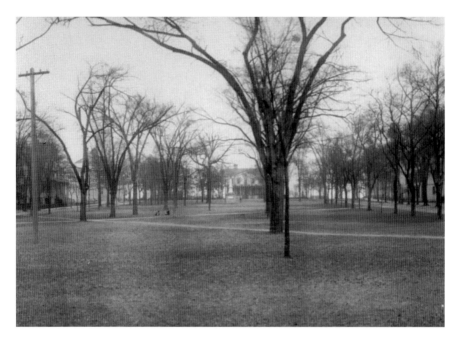

Horseshoe, University of South Carolina, circa 1909. The historic Horseshoe is the center of the university. Rutledge College, built in 1805, was the first building on campus. PAN US GEOG—South Carolina no. 11. *Courtesy of Library of Congress, Prints & Photographs Division.*

for the sons of the upstate and lowcountry to socialize and study together. The goal was to promote friendships that spanned geographical divides, thereby building a new consensus and eradicating sectional animosities. The plan exceeded expectations, and by the 1850s, most members of the South Carolina legislature and state officials were graduates of the college.

The South Carolina legislature was proud of its new institutions and generously funded the antebellum college. As a result, the school attracted national scholars, and South Carolina College developed a well-deserved reputation for the quality of its faculty and curriculum. In addition to Maxcy, the college attracted William Henry Thornwell, Thomas Cooper, the LeConte brothers, Francis Lieber and other antebellum intellectuals. Thornwell was a highly respected Presbyterian minister. Cooper, an Oxford-educated Englishman, was a deist and was proslavery, and the German-born Lieber compiled the *Encyclopedia Americana* and wrote *On Civil Liberty and Self-Government*. Lieber was uncomfortable with slavery and the idea of secession, so he left the college and joined the faculty of Columbia University.

The college used slaves—some hired and others owned by the college—to support staff, assist the stewards and maintain the college buildings and campus. Students could also "hire" slaves to assist with their personal needs. In addition, builders used slave labor to construct the college's first buildings around the Horseshoe.

The students, often away from home for the first time, posed special challenges for local law enforcement. The college had a long list of rules that forbade, among other activities, gambling, dueling and drunkenness. Yet despite college regulations, students pursued "wine, women and song." Drunken or mischievous students roamed nearby residential areas. They overturned privies, trampled flower gardens and knocked down fences. There was special animosity between students and local law enforcement. Student hijinks led to arrests and, in 1856, armed conflict between students and police.

Students also protested campus meals and campus discipline and occasionally threatened faculty. At least one professor resigned as a result of student harassment. A few disagreements led to duels and death. For example, in 1833, James Adams and A. Govan Roach clashed over a dish of fish. During the ensuing duel, Roach killed Adams. But Roach suffered a serious wound that left him an invalid. The college expelled those involved in the duel.

South Carolina College was not Columbia's only institution of higher education. In 1854, with a legislative charter, the South Carolina Conference of the Methodist Episcopal Church established Columbia Female College, now Columbia College, as a higher educational institution to educate women. The Methodist conference purchased land for the college on Hampton Street. The first class of 121 students began study in 1859.

PUBLIC IMPROVEMENTS

Bridges, Street Railway and Water

Bridging the Congaree River was a challenge. Freshets washed out the first two efforts. Finally, in 1827, the third attempt was successful. Also, by 1830, there were bridges over the Broad and Saluda Rivers. As a result, the capital was more accessible for land travel, and trade and commercial opportunities grew. For example, John McLean capitalized on the cotton passing through

the city and developed a horse-drawn street railway. Also, in 1820, the *City of Columbia*, a steamboat, pioneered river access and sailed the Santee and Congaree Rivers to Columbia.

In 1820, Colonel Abram Blanding developed Columbia's first waterworks. Blanding acquired a steam engine capable of pumping water from the base of Taylor's Hill to the eminence of Arsenal Hill. The water plant located in Seaboard Park (Sidney Park behind the post office) pumped water from the Congaree for public facilities, hotels and fire stations in Columbia's downtown. Blanding opened public baths at the plant and powered gristmills and flour mills with the steam. Later, in 1835, Blanding sold the system to the City of Columbia.

The Columbia Canal

The first serious attempt to improve Columbia's connection with the outside world was the Columbia Canal. In the 1820s, South Carolina embraced the national trend of internal improvements. One of these was the Columbia Canal, completed in 1824. On the east side of the Congaree River, engineers laid out the canal near the junction of the Broad and Saluda Rivers. Built by Irish Catholic labor, at a cost of $206,000, the canal was a major investment. Although the canal struggled economically,

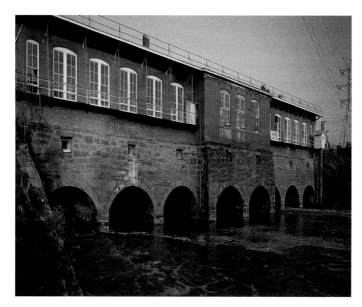

Columbia Canal and Power Plant. The power plant, owned by the City of Columbia, still generates electrical power for South Carolina Electric & Gas Company. HAER SC, 40—COLUM 18-70 (14). *Courtesy of Library of Congress, Prints & Photographs Division.*

on average, according to Lloyd Johnson, the canal carried thirty thousand bales of cotton per year en route to the port city of Charleston.[21] State subsidies ended in 1840, and with the coming of the railroad, the canal's economic importance temporarily declined.

The Catholic laborers brought to build the canal had an unexpected consequence for Columbia. Those who stayed after the project was completed formed the nucleus of Columbia's first Catholic church, St. Peter's. As a result, by the 1830s, the capital city had five houses of worship. In addition to St. Peter's, there were First Presbyterian Church, Washington Street United Methodist, First Baptist and Trinity Episcopal.

SOCIAL AND COMMUNITY DEVELOPMENT

By 1816, almost one thousand people lived in Columbia. Concerned women organized the Ladies Benevolent Society. The society was a charitable organization to minister to the needs of the poor in Columbia. A few years later, others concerned about the lack of care and treatment for the mentally ill lobbied for better care options. As a result, in 1821, thanks to the efforts of Samuel Farrow and William Crafts, the South Carolina

Original state hospital, April 1960. Architect Robert Mills designed South Carolina's first mental health facility. Built in 1828, the structure is listed on the National Register of Historic Places. South Carolina Department of Transportation, S233002. *Courtesy of South Carolina Department of Archives and History.*

General Assembly chartered the state's first mental hospital—then known as the Lunatic Asylum. Designed by Robert Mills, the original mental hospital reflected "cutting edge" design in the care of the mentally ill. In addition, the building was fireproof. According to Mills, the hospital combined "elegancy with permanency, economy and security from fire." Originally, the building had a roof garden, and all the patients' rooms faced south. Mills designed the building with a cupola to ventilate the upper stories. Workers began construction on December 21, 1821, and by December 18, 1827, the building was completed. South Carolina's State Hospital was the third publicly funded mental hospital in the United States.[22]

Robert Mills (1781–1855), the architect, was a native of South Carolina who in 1823 became South Carolina's superintendent of public buildings and, later, a federal architect. In 1836, Mills won the competition to design the Washington Monument in Washington, D.C. During his career, Mills designed numerous private and public buildings in the District of Columbia, as well as in South Carolina, Maryland, Pennsylvania, Georgia and Virginia.

LAFAYETTE'S VISIT

In 1824, the Marquis de Lafayette, the last of the Revolutionary generals, toured the United States. Accompanying Lafayette were his son, George Washington Lafayette, and Auguste Levasseur, who later published an account of the visit. In March 1825, Lafayette, his son and his secretary visited Columbia. City leaders, legislators and the governor greeted the hero with great pomp and ceremony and escorted him to the Randolph House on Gervais Street. The official celebration included speeches, receptions, a ball and a parade down a decorated Main Street. South Carolina College declared a holiday so that students could participate in the historic event.

NULLIFICATION

In the 1830s, there were new challenges to the social order. The city's population reached 3,310. Visitors filled the city's hotels, and business boomed. Yet between the years of 1828 and 1834, some citizens were concerned with tariffs, especially the "Tariff of Abominations." The

initial concern with tariffs spilled over into a sectional dispute. John C. Calhoun, then vice president of the United States, wrote the "South Carolina Exposition and Protest," setting forth the idea that a state had the right to nullify a law it considered unconstitutional or that favored one section of the country over another. In 1830, Columbia residents met to consider nullification and discuss the possibility of secession. By 1831, those who opposed the tariffs had organized the States' Rights and Free Trade Party. The new party held its first convention in Columbia. Meanwhile, Unionists who supported President Andrew Jackson also held a convention. Organized by Joel R. Poinsett in 1832, the pro-Union group met in the First Presbyterian Church.

Matters came to a head on November 12, 1832. The Nullification Convention met in the House of Representatives and enacted an Ordinance of Nullification. The ordinance declared the 1828 and 1832 United States tariffs "null and void." The United States Congress passed the Compromise

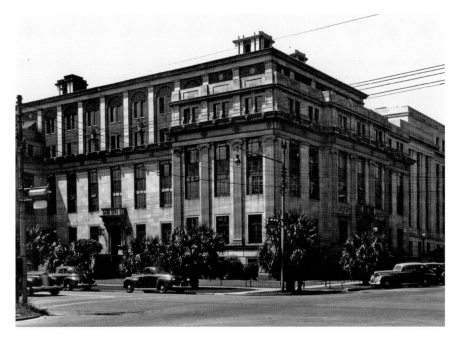

John C. Calhoun State Office Building, capitol complex. Built in 1926, the Calhoun Building housed the South Carolina State Highway Department until 1952. This building was the site of the famous standoff between Governor Olin D. Johnston and Chief Highway Commissioner Benjamin M. Sawyer. In 1935, the governor ordered the National Guard to seize and occupy the Calhoun Building. South Carolina Department of Transportation, S2330002. *Courtesy of South Carolina Department of Archives and History.*

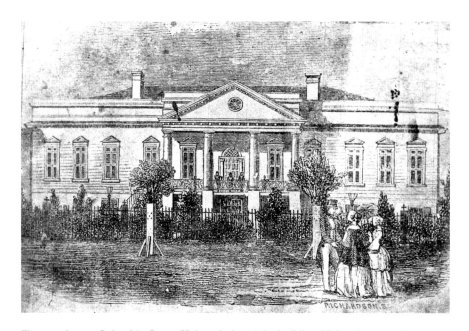

First statehouse, Columbia. James Hoban designed the building. Hoban later was the architect for the White House in Washington, D.C. Picture file 900051. *Courtesy of South Carolina Department of Archives and History.*

Tariff of 1833, which reduced tariff rates, and a force bill that gave President Jackson the right to enforce tariff legislation. In response, the nullification crisis abated, and South Carolina rescinded the Ordinance of Nullification.[23]

1840s

By 1840, the city of Columbia had 4,340 inhabitants. President Washington was not the only dignitary to visit antebellum Columbia. Perhaps surprisingly, in 1847, as sectional conflicts were on the rise, Daniel Webster, United States senator from Massachusetts, visited Columbia. Earlier, in 1830, Webster and Robert Hayne of South Carolina had famously debated the meaning of the United States Constitution and of the Union in the United States Senate. William C. Preston, the president of South Carolina College, entertained Webster. Students from the college held a torchlight procession around the Horseshoe, after which Webster addressed the students from the portico of the president's house.

Webster spent a week in Columbia before continuing his travels to Augusta, Georgia. During that week, General Wade Hampton, Dr. Robert W. Gibbes and Governor David Johnson also entertained him. An especially memorable time was Webster's visit with his former teacher, Professor Francis Lieber of South Carolina College. Residents gave a ball for Webster and planned a fishing trip. On his last day in Columbia, Webster attended services at Trinity Episcopal Church.[24]

Webster found Columbia "very beautiful" and well situated. He admired the trees planted along the streets and squares and considered Columbia "one of the handsomest and nicest looking of our little inland cities."[25]

1850s

The 1850s were times of change—political, economic and social. Of future significance, William Glaze opened the Palmetto Iron Works on Lincoln Street in 1850. While Glaze originally planned to produce ornamental ironwork, in 1851 the state contracted with Glaze and Company to produce weapons for the South Carolina militia. Glaze's company, known as the Palmetto Armory, manufactured swords, sabers, hand arms and rifles. With the surrender of Columbia during the Civil War, Union forces destroyed the armory's machinery and seriously damaged the facilities. In the years after the war, George A. Shields acquired the property and rebuilt the ironworks.

By the 1850s, rail transportation had connected the capital city with major economic centers. In 1835, Louisville, Cincinnati & Charleston Railroad launched the Branchville & Columbia Railroad. In 1842, the new rail line linked Columbia with Charleston. On June 20, the arrival of the "Robert Y. Hayne," the railroad's first locomotive, brought passenger service to Columbia. Columbia and Charleston officials celebrated with barbecue and toasts. The mayor of Columbia offered a special toast: "Charleston and Columbia: the metropolis and the capital. What man has magnificently joined together, surely God will protect against the ravages of time and the wars of the elements."[26] Also, during the 1850s, rail lines connected the capital with Wilmington and Charlotte, North Carolina, as well as Spartanburg and Greenville, South Carolina.

Rail access contributed to Columbia's position as a central transportation hub. Cotton, in particular, was a major cash crop for old Richland District. "Cotton town," an area beyond Elmwood Avenue,

was a center for the cotton trade. Columbia had cotton gins, mill storage warehouses and other ancillary cotton-related industries. The rail tracks crossed the western end of Columbia. Consequently, the rail stations, warehouses and other support enterprises clustered in the Gervais Street area. Gervais Street, as a result of the bridge across the Congaree River, was the primary east–west artery traversing the city. Yet the antebellum commercial center was still Main (Richardson) Street.

In 1852, the city's main streets had gaslights, and the city's population stood around seven thousand. The yellow and gray frame houses were gone. Brick homes, such the Robert Mills House, testified to new commercial vitality and wealth. Major new buildings at South Carolina College altered the streetscape. For example, the South Caroliniana Library, completed in 1840 and designed by Robert Mills, is a large brick structure with impressive white columns, and Drayton Hall, built in 1854, is a Greek temple at the intersection of Sumter and Greene Streets. Columbia's churches also benefited from this building boom. Influenced by Gothic-inspired architecture, the city's Episcopalians built Trinity in 1846, and the Presbyterians erected First Presbyterian Church in 1854. The Baptists constructed the classically styled First Baptist Church with great brick columns in 1859. In addition, Reverend John Lynch founded the Ursuline convent in Columbia.

A NEW STATEHOUSE

By the 1840s, South Carolina leaders were facing a dilemma. The existing statehouse lacked adequate space for storing the burgeoning collection of state records. Consequently, in 1847, officials began planning for a new fireproof building. Commissioners hired P.H. Hammerskold as architect for the project, and in 1851, construction began on a new north wing. The new wing also faced Main Street and was designed to be expanded. Within two years, the legislature decided to expand the facility. Therefore, it purchased additional land and doubled the size of the statehouse square. Also, to accommodate the new building, workmen moved the old statehouse.

Yet by May 1854, the commissioners of the statehouse had serious concerns about the new building. Major cracks had appeared in the new walls and arches. As a result, the commissioners suspended P.H. Hammerskold and contacted John Rudolph Niernsee, a Viennese architect who had studied in Prague, to review the condition of the building. Niernsee found inferior

Right: John Rudolph Niernsee (1814–1885), engineer and architect of the South Carolina Statehouse. A native of Austria, Niernsee formed a partnership and practiced in Baltimore before winning the commission to design the South Carolina statehouse. Picture file 900051. *Courtesy of South Carolina Department of Archives and History.*

Below: Drawing of proposed new South Carolina Statehouse, *Harper's Weekly*, December 1, 1860. This sketch may represent a presentation drawing prepared by architect John Niernsee. Despite Niernsee's plans, the present statehouse has a dome and not the proposed tower. When Columbia was burned in 1865, Niernsee's original plans were lost. Picture file 900051. *Courtesy of South Carolina Department of Archives and History.*

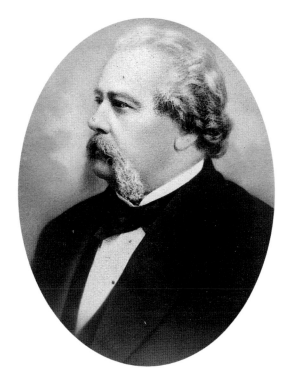

construction with poor materials. In August, the commissioners named George W. Walker to fill the position of superintending architect. Walker and Niernsee examined the building and found the construction unsatisfactory. At that time, the General Assembly fired Hammerskold and ordered existing work razed.

In December 1854, despite the debacle, the General Assembly voted to continue with the project, as "the State has already expended a large amount of money, the greater portion of which is represented by material prepared for use, which will become a dead loss unless made available in the construction of a Capitol." Under the direction of Niernsee, construction began on a new statehouse that faced Gervais Street. Workers quarried stone for the new statehouse at the nearby Granby quarry. Despite the outbreak of the Civil War, work on the statehouse proceeded. But when Sherman and his troops attacked Columbia, the new statehouse was still incomplete. The exterior walls rose to the frieze level. Shells fired by Union troops struck the building—six struck the west front and ten hit the interior.[27]

FREEDOM OF THE PRESS

In 1855, with the winds of war in the air, an unlikely conflict developed. Dr. Robert Wilson Gibbes squared off with the Columbia City Council. By training, Gibbes was a medical doctor, yet by 1852, he owned two of Columbia's newspapers, the *Palmetto State Banner* and the *Daily South Carolinian*. Gibbes merged the two and published under the banner of the *Daily South Carolinian*. Gibbes's paper affected nonpartisanship but opposed the candidacy of Columbia mayor E.J. Arthur. Gibbes wanted to publish proceedings of the city council. Nevertheless, when he asked for access, Mayor Arthur "stonewalled." So, Dr. Gibbes formally requested an abstract of council's proceedings and permission to have a reporter present. Council refused, as it had an exclusive contract with another printer. In other words, under Arthur, the Columbia City Council had offered "first publication" rights to one Columbia newspaper. To Gibbes, the actions of Arthur and city council challenged "the right of a citizen to attend…public meetings and report their proceedings." A defiant Gibbes attended a council meeting and exchanged barbed remarks with the mayor—at which point Arthur ordered the marshal to eject the editor.

Gibbes took the matter to court and sued for damages. Richard Yeadon, one of Gibbes's attorneys, argued that he was a "champion of the liberty of the press." In summary, Yeadon eloquently asserted, "Liberty of the Press does not rest alone upon Miltonic prose and verse, but upon the constitution of our state and the nation. It is the most sacred of our rights." On March 14, 1857, the jury deliberated and awarded Gibbes damages against the mayor, Edward J. Arthur, and against John Burdell, the marshal. Presses in the state celebrated the victory. But within a few months, Gibbes ceased active management of the paper. The fire that destroyed Columbia in February 1865 also burned the newspaper's office and equipment.[28]

WAR REFUGE

All safe here.

–Eliza C. Ball, 1863

In 1860, tottering on the cusp of war, Columbia reported a population of slightly more than 8,000—a distant second to Charleston. Columbia's free black population was only 321. Nevertheless, the city's slave population numbered 3,500. According to David Stowall, the average age for a free person of color in Columbia was twenty-three. In Columbia, most free persons with an occupation listed on the United States Census had one of three occupations: carpenters, seamstresses or laundresses. Yet, surprisingly, the city directory listed only one free black barber.[29]

While, technically, some may contend that the Civil War began in Columbia, in 1860 popular sentiment was not universally secessionist. Nevertheless, in the wake of the November 13 election of Abraham Lincoln, the first Republican president of the United States, the South Carolina legislature called an election on December 6 to choose delegates to consider the future of the state of South Carolina. According to Charles H. Lesser, the delegates included five former governors, college and railroad presidents, clergymen and planters. Most owned slaves and had served in the South Carolina General Assembly, and 90 percent were South Carolina natives.

In 1860, two of the delegates were residents of Columbia: Maxcy Gregg (1814–1862) and William Ford deSaussure (1792–1870). Gregg, a native of Columbia and graduate of South Carolina College, was a lawyer and grandson of Jonathan Maxcy, the first president of South Carolina College.

A veteran of the Mexican-American War, at the time of his death Gregg was a brigadier general in the Confederate States army. Mortally wounded at the Battle of Fredericksburg, Gregg died on December 15, 1862, and on December 20 was buried with full military honors in Elmwood Cemetery, exactly two years after he signed the Ordinance of Secession. Today, Maxcy Gregg Park on Blossom Street honors his memory.

William Ford deSaussure was also a Columbia lawyer and had served briefly in the United State Senate (1852–53). Born in Charleston, DeSaussure was a Harvard graduate and was politically active in South Carolina. He served two terms as mayor (intendent) of Columbia and in the South Carolina House of Representatives and, in addition, was a chancellor (judge) in the court of equity.

SECESSION

On December 17, the convention of newly elected delegates convened in the recently built and not quite finished sanctuary of the First Baptist Church on Hampton Street, and there it elected David F. Jamison, a delegate from Barnwell, as president. On the first day, the delegates unanimously adopted a resolution that "the State of South Carolina should forthwith secede from the Federal Union."

Before appointing a committee to draft such a document, the chair adjourned the session in Columbia and reconvened the convention at Institute Hall in Charleston. There, on December 20, all 169 delegates solemnly signed the Ordinance of Secession repealing the United States Constitution and severing the state's ties with the federal government, briefly creating an independent state of South Carolina. When news of secession reached Columbia, in a great uproar, residents celebrated. They fired cannons, rang bells and lit large bonfires on Main Street. Excitement reigned,[30] and South Carolina College students organized a military company.

Yet tension underlay the heady euphoria of independence. For example, that Christmas, rumors circulated about a possible slave insurrection, and by spring, companies of Columbia men had left for service in Charleston. According to J.F. Williams, the first companies deployed were the Columbia Grays and Governor's Guards. But not all Columbians supported secession or slavery. For example, because of his political views, vigilantes tarred and feathered P.F. Frazee, who operated a carriage manufacturing facility at the corner of

First Baptist Church and Sunday School Building, Columbia, S.C.

First Baptist Church, Columbia. In 1860, the South Carolina Secession Convention initially convened in the recently completed sanctuary of the First Baptist Church of Columbia. The convention moved to Columbia, where all the delegates signed the Ordinance of Secession. Columbia Cigar & Tobacco Company, Columbia. *Collection of the author.*

Washington and Assembly. In another instance, singing "The Star-Spangled Banner" cost a man not only his job but also his freedom. He was turned over to the conscription officer and was enlisted in the Confederate army. Troops from upstate congregated in Columbia and trained at the fairgrounds off Elmwood. Later, troops trained at Lightwood Knot Springs near Killian. At that time, Confederate officials used the fairground facilities as a hospital. After the hospital moved to the campus of the South Carolina College, Joseph LeConte, professor of chemistry and geology at the college, established a plant to manufacture saltpeter at the fairgrounds.

Following the signing of the Ordinance of Secession, the student body attempted to form a company. Although involved with guard duty in Charleston, the students' quest to enlist for active duty faced a number of hurdles. In a sense, the students were caught in a Catch-22. On the one hand, unless the faculty approved, Governor Francis W. Pickens did not want the students to enlist en masse. But on the other hand, faculty members did not want the college closed. So, they opposed mass enlistment. With a general call to arms, most of the students did enlist in Confederate service, and as a result, the college closed in 1862. During the Civil War, college buildings housed hospital patients, not students.

Secession affected other education institutions as well. In 1862, after secession, Dr. Elias Marks and his wife leased the Barhamville Academy (also known as the South Carolina Female Collegiate Institute) to Madam Acilie Togno, who had a school in Charleston. Yet a year later, Togno leased the facility to Madam Sophie Sosnowski. Although the school escaped destruction in 1865 (thanks to the intervention of Federal troops), Madam Sosnowski abandoned the school and moved to Athens, Georgia. Ironically, the school burned down in 1869.[31]

In 1862, under the aegis of Colonel James Chesnut Jr., chief of Military Department of the South Carolina Executive Council, LeConte published *Instructions for the Manufacture of Saltpetre*. After the Civil War, in 1869, the newly organized University of California hired Joseph and his brother, John, as professors. Joseph LeConte made significant contributions in the study of paleontology and natural history. Several schools and two mountains—Mount Le Conte in the Sierra Nevada near Lone Pine, California, and Mount Le Conte in the Great Smoky Mountains near Gatlinburg, Tennessee—are named for him. Joseph's brother, John LeConte, also served as president of the University of California. In 1892, Joseph LeConte, John Muir and others founded the Sierra Club. LeConte had a special interest in the preservation of Yosemite.

CIVIL WAR COLUMBIA

To many, Columbia was the safest city in the Confederacy. State banks shifted their deposits to Columbia. Lowcountry residents sent plate, artwork and other valuables to Columbia for safekeeping. In 1864, Evans & Cogswell relocated its printing operation from Charleston to Columbia. Evans & Cogswell was the official printer and lithographer for the Confederate States of America. The printing firm erected a plant at the corner of Gervais and Pulaski and employed scores of young women. Partially destroyed by Union forces, the State of South Carolina later purchased the building as a warehouse for Governor Ben Tillman's "baby": the State Dispensary. Other printing companies, including Keating and Ball of Richmond, also relocated to Columbia.

Columbia was also home to a wide array of war industries. Originally, the Palmetto Iron Works (Palmetto Armory) converted muskets into percussion weapons. During the Civil War, the plant produced arms, cannons and munitions such as Minié balls (bullets). Other manufacturing enterprises produced uniforms, side arms, sabers and other war materials. For example, Kraft, Goldsmith & Kraft produced swords. Other shops and factories produced guards for swords, uniform buttons, matches and socks, shoes, rifles and hats for the soldiers. At the old fairgrounds (near Elmwood Avenue), a

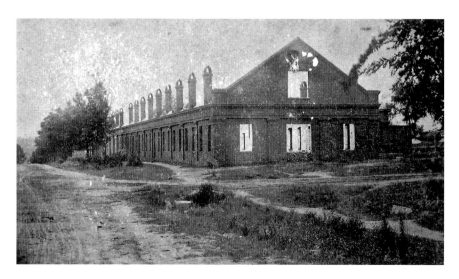

Evans & Cogswell Printing, carte-de-visite, 1865. Evans & Cogswell was one of several printing plants that moved its operations to Columbia during the Civil War. Burned in 1865, the plant, located at the Gervais and Pulaski Streets, was rebuilt and later housed the South Carolina Dispensary. Richard Wearn, photographer. Photographs Wearn 19. *Courtesy of South Carolinian Library, University of South Carolina.*

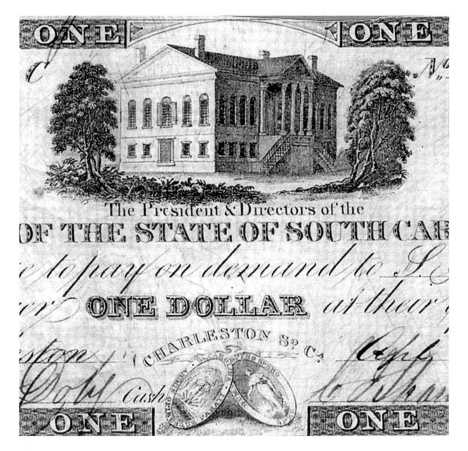

First statehouse, Columbia, One Dollar Note, Bank of the State of South Carolina, 1862.
Courtesy of South Carolina Department of Archives and History.

government laboratory manufactured alcohol, chloroform and related items for medical purposes. A distillery on the site also produced whiskey. Near the Columbia Canal, Professor Joseph LeConte oversaw a plant that produced saltpeter and gunpowder. In addition, across the Congaree River, the Saluda Factory, one of the state's few textile mills, produced cotton cloth.[32]

In 1862, after the Battle of Port Royal, the South Carolina Executive Council, an extralegal body secretly ordered state officials in Charleston to transfer state records in its keeping to Columbia for safety. With the occupation of Beaufort and the Sea Islands, military and political leaders in South Carolina expected Union troops to attack Charleston. As part of the compromise to relocate the capital to Columbia, legislators agreed in 1790 that there would be two offices of the secretary of state and a treasurer of the lower division as well as a treasurer

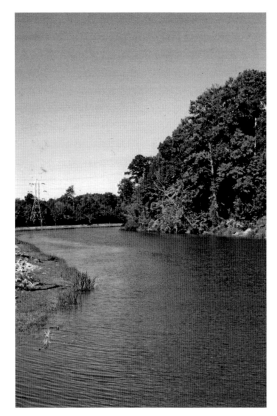

Left: Columbia Canal, 2014. Built in 1824, the Columbia Canal was part of South Carolina's interest in internal improvements to facilitate commerce. Although the canal had limited impact on water transportation, it later made Columbia a manufacturing center. *Photograph by Terry L. Helsley.*

Below: Chesnut Cottage, Hampton Street, 2014. For a time during the Civil War, Mary Boykin Chesnut, wife of Colonel James Chesnut, lived in this house. In 1864, President Jefferson Davis visited the Chesnuts and addressed the citizens of Columbia from the front steps of the house. *Photograph by Terry L. Helsley.*

of the upper division. Hence, state offices in Charleston held state land records, tax returns and records for the lower district. When the records arrived, officials stored them in the basement of the yet-unfinished statehouse. Other counties, such as Beaufort, also reportedly sent their records to Columbia for safekeeping.

Columbia women organized to aid the war effort. In addition to compiling supplies for the soldiers, on March 10, 1862, a group of Columbia women founded on Gervais Street the first Wayside Hospital to care for sick and wounded Confederate soldiers. Supported entirely by voluntary contributions, the Wayside hospital not only ministered to an estimated seventy-five thousand men but also inspired other Southern communities to establish their own Wayside hospitals.

During the Civil War years, Confederates used the Columbia Canal as a source of power. The canal generated power for a gunpowder manufacturing plant. This Civil War usage brought a glimmer of a different postwar future for the canal.

At first, Columbia residents faced few shortages. However, in time, the Union blockade did affect the city. Coastal shortages and uncertainties produced thousands of refugees seeking shelter in the capital city. Some planter refugees brought their household servants with them. Yet when a blockade runner successfully landed with a cargo of necessities and luxuries, shoppers were euphoric. According to Mary Boykin Chesnut, their sale on the streets of Columbia brought crowds and mayhem worthy of any successful Black Friday blockbuster. During the war, the noted diarist and her husband, General James Chesnut, temporarily made Columbia their home. The Chesnuts lived on the 1700 block of Hampton Street.

PRESIDENT JEFFERSON DAVIS

There, in October 1864, the Chesnuts entertained Jefferson Davis, the president of the Confederate States of America. Standing on the steps of the cottage, Davis addressed the residents of Columbia, including school students released from classes for the occasion. Davis spoke at length, encouraging his audience. He noted that South Carolina "has struggled nobly in the war" but remained firm. He predicted that if one-half or even one-fourth of eligible Southern men would serve, he saw "no chance for Sherman to escape from a defeat or a disgraceful retreat." He carefully explained setbacks, defeats and retreats. Yet Davis commended South Carolina, noting its "brave sons battling...

everywhere," and "Fort Sumter, where was first given to the breeze the flag of the Confederacy." He also appealed to the memory of the "immortal John C. Calhoun" and expressed gratitude for "the fair country-women of the Palmetto State" and their efforts to establish and operate wayside hospitals. Davis ended his address with a plea for all "absentees" to join the army, as there was much to be done "within the next thirty days."[33]

The city's population more than doubled with war refugees and their families and slaves. Demand dramatically outstripped supply. Rooms and beds were in short supply. For example, the Columbia city directory for 1860 listed only eleven boardinghouses and four hotels. Some stayed with friends or relatives. Other refugees moved farther inland to Aiken or Greenville. With the blockade and so much manufacturing capacity diverted to the war effort, shortages increased. Residents coped with poor but expensive salt and no sugar or coffee. Inflation was rampant, as the price of flour rose to $500 per barrel and brown sugar $6 per pound; a gallon of whiskey was $60. Even after the burning of Columbia, according to Emma LeConte, calico—the least expensive material available— cost $25 to $35 per yard. Some refugees, such as the Leverett family of Beaufort District, repaired to their farm in Columbia on the Barhamville Road and raised as much of their food as possible.

The prescient young Emma LeConte, teenage daughter of Professor Joseph LeConte, on December 31, 1864, wrote, "The last day of the year—always a gloomy day—doubly so today…I cannot look forward to the new year— 'My thoughts still cling to the mouldering past!' Yes, the year that is dying has brought us more trouble than any of the other three long dreary years of this fearful struggle."

Sherman and his army marched through Georgia and, by years end, held Savannah. LeConte and others looked ahead to a new year of similar destruction in South Carolina.

COLUMBIA IN 1865

[A] very handsome place situated near the river…regularly and tastefully laid off, and the wide streets are shaded by rows of trees…
 —George Whitfield Pepper, 1865

By 1865, Columbia was a city in crisis. The gaslights ceased working in 1864. The small constabulary found it difficult to cope with opportunistic

street crime and bootlegging. Illegal saloons flourished, and only the most adventurous or foolhardy walked downtown streets at night. In the waning years of the war, weak penalties and devalued currency further exacerbated law enforcement efforts. With minimal fines, bootleggers considered them the price of doing business.

Highly combustible cotton joined the ranks of refugees, and as volume far exceeded available storage, bales were piled high in alleys and on vacant streets. Occasional fires broke out, and Columbia's firefighters were pressed to address the need. After 1863, conscription claimed most if not all the able-bodied men in Columbia—drastically limiting the pool available for law enforcement and firefighting.

CAMP SORGHUM

Near the old Saluda factory, in September and October 1864, Confederates operated a prisoner of war camp. Known as Camp Sorghum, for the limited diet afforded the prisoners, the camp housed 1,300 Union officers in a space, according to George Whitfield Pepper, adequate for perhaps 500 men. Other accounts suggest that the camp housed 1,700 men. The men lived in the open without shelter, subject to the elements. Late in their confinement, the guards permitted them to dig holes in the ground for partial protection. Prior to Sherman's arrival, the Confederates moved the prisoners. A few escaped detection and were rescued by Union soldiers.

"GREAT BAZAAR"

As a flame sometimes burns brightest just before it goes out, Confederate Columbia had one last hurrah. To raise funds for the Wayside hospitals, Confederate women and others organized a great fair. South Carolina and the Southern states (Georgia, North Carolina, Mississippi, Louisiana, Missouri, Texas, Tennessee, Florida and Virginia) sponsored exhibits with rare and costly items for sale. Amazingly, large quantities of turkey, ham and other seldom-seen luxuries were abundantly available. The endeavor raised, by some estimates, $200,000 in Confederate funds. On January 22, 1865, Sarah Goodwyn wrote to her husband, Artemus Darby Goodwyn,

describing the festivities. Sarah's father-in-law was Thomas J. Goodwyn, mayor of Columbia. She noted that the "old State House presented a most magnificent appearance." Each table had a canopy of "lace and crimson," with "the shield of each state and a large flag drooping over the whole canopy." Fittingly, the South Carolina exhibit stood in the House chamber near the Speaker's desk. In addition to her description of the event, Sarah also commented, "It really was worth seeing and I am truly glad Sherman did not interrupt us."[34]

By February 1865, after years of incessant war news and lengthening casualty lists, the city was numb. The inhabitants were drained and weary of war shortages and spiraling prices. Then terrorizing dispatches arrived, roiling the populace and banishing apathy. General William Tecumseh Sherman, the Union general who had brought "total war" and destruction to Atlanta in September 1864, was slashing his way through South Carolina. His infamous "March to the Sea" had devastated a swathe between forty and sixty miles wide through Georgia en route to Savannah. On December 21, Sherman notified President Abraham Lincoln of his early Christmas present. Sherman and his troops crossed into South Carolina, spent time in Beaufort (behind Union lines). After this brief respite, he divided his army and marched inland. Even then, no one expected that Columbia was Sherman's goal. Many still clung to the idea that Charleston, after months of damaging bombardment, was the ultimate prize. By the time doom loomed, many Columbia residents seemed paralyzed—like a rodent hypnotized by a boa constrictor.

SAVING THE RECORDS

There were, however, exceptions. City officials debated their options while military commanders weighed their possibilities. In addition, several state officials organized to save many of South Carolina's valuable records. Of special note are the efforts of State Auditor James Tupper, Secretary of State William Richard Huntt and Comptroller General James Black. Tupper coordinated efforts and furnished labor and supplies.

Huntt used his mother's slaves and wagon to load ninety wooden crates with the records in his custody. Huntt had served as surveyor general before his election in 1863 as secretary of state. These records included the legislative acts, journals of the General Assembly, copies of the state's four

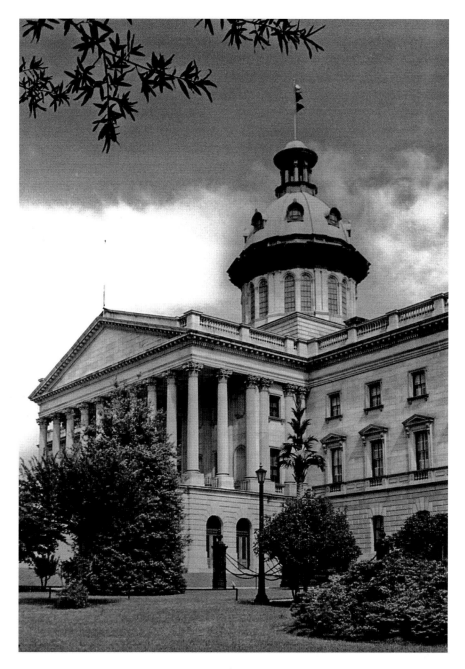

The statehouse. Workers used granite quarried in Granby to erect the new statehouse. Bronze stars on the walls of the statehouse mark the spots where Union shells struck the unfinished building in 1865. South Carolina Department of Transportation, S233002. *Courtesy of South Carolina Department of Archives and History.*

constitutions, the silver matrix for the great seal of the state, the Ordinance of Secession, colonial and state grants and plats and the miscellaneous records that dated from 1671. Huntt loaded the boxes of records on a boxcar and took them out of Columbia on the Charlotte railroad. Eventually, he hid the records on a side rail near Chester. On June 11, 1869, Huntt, aged thirty-five, died of consumption. He left a widow and three young children.[35]

In addition, in 1907, William Hood, treasurer of the upper division, wrote to Edwin L. Green. In the letter, Hood described his efforts to preserve the records in his custody. In 1865, Hood had the records of his office at his Newberry home. With the burning of Columbia, Hood loaded those and other records he had found in Chester and moved them by wagon to Newberry.[36]

Today, attorneys, family researchers and historians use these materials to answer questions about South Carolina's rich history. These rescued records, as well the tax records preserved by Comptroller General Black, are now housed in the South Carolina Department of Archives and History.

The days of uncertainty ended when a forward detachment occupied the heights near the Saluda Factory. Union artillery found their range, with some shells striking the granite walls of the unfinished statehouse. Today, when school students tour the statehouse, the docents routinely point out the brass stars on the building's exterior. These stars mark the physical evidence of the bombardment—a lasting memorial to Columbia's darkest hour.

Yet even with doom on the doorstep, President Jefferson Davis could offer little military assistance. He sent General Wade Hampton III with his cavalry. South Carolina's neighbor, Georgia, also offered little aid. But then South Carolina had not aided beleaguered Georgia troops as Sherman marched through their state.

BURNING OF COLUMBIA

By February 16, 1865, Sherman and his fifty-eight thousand battle-hardened men were poised to occupy South Carolina's capital city. With the end at hand, roving bands of "displaced" soldiers and residents ransacked businesses on Main Street and unearthed hidden caches of flour and other highly desired consumer goods. Mob violence spread beyond the city center to warehouses and other commercial properties. Due to crossed communications, Hampton ordered cotton pulled into the streets for burning, and then General P.G.T. Beauregard countermanded the burning order. Hampton

then issued an order not to burn the cotton—leaving combustible materials littering Columbia's business district. Captain Rawlins Lowndes, Hampton's adjutant, recorded, "Soon after General Hampton assumed command of the cavalry, which he did on the morning of the 17th of February, he told me that General Beauregard had determined not to burn the cotton, as the Yankees had destroyed the railroad, and directed me to issue an order that no cotton should be fired." Unfortunately, the South Carolina Railroad had been destroyed, so the cotton could not be removed by rail. The stage was set for a "perfect storm of destruction."[37]

On the morning of February 17, 1865, the remaining Confederate force informed Thomas J. Goodwyn, Columbia intendent (mayor), that it intended to abandon the city. In 1860, according to the census entry, Goodwyn was a sixty-year-old physician who owned real estate valued at $12,000. In an effort to slow the Union advance, retreating Confederates burned both the Broad and Congaree River Bridges. In turn, Sherman's troops built a pontoon bridge and, on February 17, moved across the Broad River. That day, Goodwyn wrote to Major General Sherman:

> *The Confederate forces having evacuated Columbia, I deem it my duty, as Mayor and representative of the city, to ask for its citizens the treatment accorded by the usages of civilized warfare.*
>
> *I therefore respectfully request that you will send a sufficient guard in advance of the Army, to maintain order in the City and protect the persons and property of the citizens.*[38]

More bad news followed. Midmorning, a deadly explosion rocked the South Carolina Railroad depot. As their parting shot, retreating Confederates fired the Charlotte depot. Between eight and nine o'clock in the morning, Goodwyn and three councilmen met Sherman's representative, Colonel G.A. Stone, on River Drive and officially surrendered the city. As Confederate troops had burned the Congaree River Bridge, Union forces arrived over hastily constructed pontoon bridges. Consequently, Stone's troops, the first division, Fifteenth Army Corps, were the first Union soldiers to enter the capital. Members of the Fifteenth Corps were from Iowa. On February 19, 1865, Stone reported that about one mile from Columbia, his men encountered Mayor Goodwyn and the councilmen in a carriage bearing a flag of truce. Stone insisted on unconditional surrender and then joined Goodwyn in the carriage for the trip to the capital. En route, Stone noticed Confederate cavalry skirmishing with his front men. At that time, Stone left Goodwyn

and the councilmen in the care of a corporal and, with a detachment of his troops, pursued and dispersed the cavalrymen. Before leaving Goodwyn, Stone warned the corporal "that in case one man was killed or wounded, he should at once shoot the mayor and his party." Fortunately for all concerned, the party reached the statehouse without incident, and Stone planted the United States flag on the building.[39]

By 11:00 a.m., Union troops controlled South Carolina's capital city. As the victorious army entered the city, black and white residents greeted them with liberal offerings of whiskey and other spirits. Whether the greeters' goal was to ingratiate themselves with the conquerors, or whether they just wanted to "mellow out" the victors, as with the cotton, the result was catastrophic.

While Union general Oliver O. Howard, a native of Maine known as "the Christian General" and educated at West Point, ordered the stock of spirits destroyed, the situation remained volatile. Depots smoldered, the bridge was still warm to the touch and drunken civilians and soldiers wandered the streets of the prostrate city. With disorder rampant, Howard ordered new troops to arrest the drunk and disorderly. By 8:00 p.m., Main Street (then known as Richardson) was engulfed in flames.

Wooden buildings burned quickly, and a high wind spread sparks from building to building. Despite efforts of the fire brigades and assigned military reinforcements, by 11:00 p.m. Main Street was in ruins.

In 1860, Columbia had four fire companies: the Independent Fire Company, with an engine house on Main Street; Palmetto Fire Company, with an engine house on Blanding Street; Phoenix Hook and Ladder Company, with a truck house near Sidney Park; and the Vigilant Fire Company, with an engine house on Laurel Street.

According to J.F. Williams, "in a few minutes' time the whole of Main Street…was in flames." Williams also noted that the only structure on Main Street that survived the fire was the "home of Alex Riley." The Irish-born Riley's house stood on the east side in the nineteenth block of Main Street.[40]

The Main Street fire was one of three major fires that burned in Columbia that night. There was also a fire in the red-light district and another fueled by cotton stored in the middle of Sumter Street.

Riots also erupted in the streets of Columbia. Union soldiers accosted and robbed civilians. Roving gangs plundered homes and set houses afire. In a particularly egregious example, inebriated soldiers set fire to the home of Dr. Robert W. Gibbes, a collector of Revolutionary manuscripts and a paleontologist. The fire destroyed Gibbes's library and his extensive natural history collection. Fortunately, his Revolutionary materials survived. On

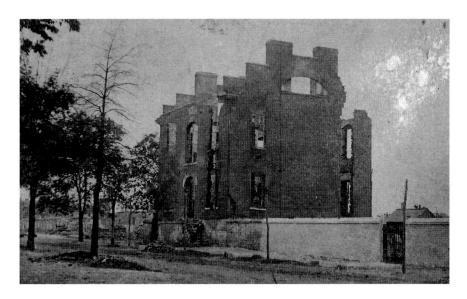

Residence of Dr. Robert W. Gibbes, surgeon general of South Carolina, carte-de-visite, 1865. Fire destroyed not only the Gibbes home but also his extensive library and natural history collection. Richard Wearn, photographer. Photographs Wearn 11. *Courtesy of South Caroliniana Library, University of South Carolina.*

March 14, 1865, Gibbes sent a letter to his son, Allston, describing the devastation. According to Gibbes, he "carried nothing out but a bag with my bonds and money" and only saved the clothes he was wearing. He lost all his family papers, photographs and library. Adding insult to injury, the fire caused bottles of rum and brandy to burst, and the heat ruined the wine in his cellar.[41]

Despite the widespread chaos, stories of Union heroism as well as debauchery survive. For example, according to Harriette Kershaw Leiding, a young soldier intervened to save the Hampton Preston House.[42]

By the wee hours of the morning on February 18, the wind abated and new troops arrived. In the course of suppressing the riot, troops arrested 370 civilians and soldiers. During the unrest, 2 died and 30 were wounded. The eighteenth dawned, and early light revealed an image of unbelievable destruction. Houses, public buildings and businesses were gone—vast expanses of smoking chimneys and rubble dotted the landscape. In the final analysis, according to Marion Lucas, about one-third of Columbia burned—458 buildings including 265 homes.[43] Offering a firsthand view, Emma LeConte, daughter of Professor Joseph LeConte, wrote in her diary on February 18, "The sun rose at last, dim and red through the thick murky atmosphere. It

set last night on a beautiful town full of women and children—it shone dully down the morning on smoking ruins and abject misery."

The burning of Columbia became a rallying point for postwar discontent. Residents remembered the event and passed on their recollections to future generations. Many residents reacted with contempt for the Union and its troops. For example, Emma LeConte wrote in her diary on February 17, "We cannot look at them [Yankees] with anything but horror & hatred."

On April 16, LeConte entered a description of the statehouse site. As she walked by the site, LeConte noted a "wilderness of granite and marble" and "piles on piles of white and Tennessee marble blocks, cracked, broken and smoke-begrimed." She also noted the fates of some of Columbia's most illustrious refugees: the bells of St. Michael's in Charleston. Either to be melted down for military repurposing or for their safety during the bombardment of Charleston, the bells had been sent to Columbia. Prior to the burning, the bells were stored in outbuildings on the statehouse grounds.

On May 7, 1865, Emma LeConte recorded a walk downtown in the moonlight. She and her party traversed Sumter "as far as the eye could reach only…chimneys" and turned onto Blanding Street. She poignantly commented that "the handsome residences made the most picturesque ruins." While Columbia's commercial center was in ruins, several important institutions survived the fire. These included the unfinished statehouse, the buildings of the South Carolina College and the South Carolina mental hospital.

In the aftermath of the fire, survival was of paramount importance. Sherman and his army continued their march, leaving dazed residents to cope. In addition to issues of shelter and shock, residents also faced food shortages. Money was in short supply and employment opportunities slim. Many had also lost most or all their clothing and scrounged for possibilities. For example, Joseph LeConte found himself in such desperate straits that he appropriated clothing from a dead Union soldier. For food, although Sherman had left cattle and other foodstuffs, many residents often had to depend on the largesse of neighboring planters or acquaintances who had looted downtown stores.

Yet, surprisingly, not all was "doom and gloom." Joseph LeConte noted the remarkable resilience of Columbia residents. For example, LeConte commented on the "real social enjoyment" that characterized Columbia society in 1866 and 1867. According to LeConte, "Society was really gay, the necessary result of the rebound from the agony and repression of the war."[44]

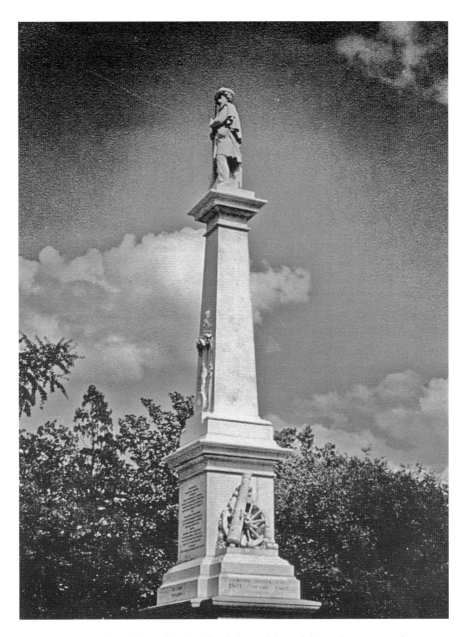

Monument to the Confederate Dead, a Confederate Memorial, statehouse grounds. Designed by the Italian sculptor Nicoli, the monument honors South Carolinians who died during the Civil War. William Henry Trescot of Beaufort wrote the inscription, which ends with the stirring words, "That Truth, Courage and Patriotism Endure Forever." South Carolina Department of Transportation, S233002. *Courtesy of South Carolina Department of Archives and History.*

On April 22, 1867, Columbia residents met at Carolina Hall. E.J. Arthur presided. The group appointed a committee to collect evidence about the burning of the city of Columbia. Members of the committee included J.P. Carroll, William F. deSaussure, E.J. Arthur, John Fisher, William Reynolds, D.H. Trezevant, A.N. Talley, W.J. Rivers, John LeConte (brother of Joseph LeConte), J.T. Sloan and L.D. Childs.[45]

Adjusting to this new world of destruction, disappointment and defeat, South Carolinians turned to remembrance and veneration of the "Lost Cause." Women, in particular, organized associations and erected monuments honoring Confederate heroes. For example, the women of South Carolina erected the Confederate monument on the statehouse grounds. ("Erected by the women of South Carolina for South Carolina's dead of the Confederate army.") William Henry Trescot wrote the inscription for the monument, including the following lines: "[C]onstant in their love for the State, died in the performance of their duty."[46]

CUSP OF REVOLUTION

We hold these truths to be self-evident, that all men are created equal
—Declaration of Independence, 1776

South Carolina African Americans not only made political and civil advances during the postwar years, but they also gained educational opportunities in Benedict College and Allen University. In 1881, the African Methodist Episcopal Church founded Allen University. Richard Allen, the school's namesake, founded the denomination. Allen is an outgrowth of Payne Institute, organized at Cokesbury in 1871. Established to educate AME clergymen, Allen opened with six professors and sixty students. In addition to theological education, Allen was also one of the few black colleges to offer a law degree. Daniel Augustus Straker, an esteemed black lawyer, joined the law faculty at Allen in 1882. In 1884, he was also an unsuccessful candidate for lieutenant governor. The Allen University law school survived into the twentieth century. In addition, the school offered industrial and agricultural training.

Across Taylor Street is the campus of Benedict College. In 1870, the American Baptist Home Mission Society founded Benedict College. Stephen and Bethsheba Benedict, the college's namesakes and benefactors, were Rhode Island abolitionists. For many years, the college had white presidents. But in 1929, Dr. J.J. Starks became Benedict's first African American president. On April 20, 1987, the Benedict College Historic District was added to the National Register of Historic Places.

Chappelle Administration Building, Allen University, Harden Street and Taylor Street, 1930s. The building honors William David Chappelle, an AME minister who founded the AME Printing House in Nashville, Tennessee. Chappelle twice served as president of the university and, in 1912, was named an AME bishop. Photographs WPA-PL-C-V-5. *Courtesy of South Caroliniana Library, University of South Carolina.*

With the organization of these institutions, Columbia became a center of African American education in South Carolina. In succeeding decades, the colleges became nuclei for prosperous black neighborhoods. Professionals and businessmen built substantial brick homes in the blocks off Harden Street—the historic Waverly residential district. But the displaced white elite clung to past memories and planned how to regain past glories. Many, such as Emma LeConte, celebrated the assassination of Lincoln. Rejoining the Union was not a desired outcome, and black political power was equally egregious.

Columbia recovered slowly. On 18 May, Union troops occupied the capital and placed the city under military rule. But commerce resumed. For a time, it appeared to the Columbia elite that there was hope. With the assassination of Lincoln, Andrew Johnson became president. He introduced his plan to readmit the seceded states to the Union. In South Carolina, he asked former Unionist Benjamin F. Perry to convene the legislature to rescind the Ordinance of Secession, ratify the Thirteenth Amendment to the United States Constitution

and call a new Constitutional Convention. These steps were necessary in order for South Carolina to be readmitted to the Union with full prewar privileges. Perry pushed for compliance, but newly elected members of the legislature refused to abrogate secession and enacted the infamous "Black Codes"—a thinly veiled attempt to reestablish white supremacy in the state. Rather than "slaves," black South Carolinians were called "servants." In addition, they had limited civil and economic rights. For example, a black worker could not be absent from his place of work without the owner's permission.

In reaction, the United States Congress enacted several pieces of legislation establishing what became known as "Congressional Reconstruction." Under these acts and the Fourteenth and Fifteenth Amendments, the newly freed men gained citizenship and the right to vote. Many registered with the newly formed Republican Party. Consequently, for the first time in South Carolina's long history, African Americans voted and held public office.

While Columbia had an active free black community in 1860, most worked as barbers (though only one was listed as such in the census) or in the service industry. By 1870, economic opportunities had improved for black Columbians. Some invested in real estate or insurance. Nash operated a brickyard, and other black Columbians worked as masons and carpenters. For a number of years, the Vigilant, a black fire company, served Columbia. In addition to black barbers, Columbia had black tailors, black ministers, black grocers and black morticians.[47]

But black and white residents rarely mingled socially except at political events or the salons held by the Rollin sisters. While a few African Americans returned to their prewar congregations, many organized their own churches. For example, in 1866, Columbia residents organized Bethel AME Church. During the 1960s, the church's sanctuary on Sumter Street was a meeting place for civil rights groups. One year earlier, black Baptists organized Calvary Baptist Church. For a time, the congregation met in the basement of the Mann-Simmons Cottage.[48]

Following the Civil War, a federal garrison occupied Columbia. Federal forces used rooms on the college campus. State officers, such as the state treasurer, also had offices there. President Johnson appointed Benjamin F. Perry as provisional governor. From January 1866 to August 10, 1868, James Orr served as governor. In 1866, the Bank of the State of South Carolina erected a facility on the Main Street. When completed, the governor, comptroller general, secretary of state and treasurer had offices there. Prior to that time, the secretary of state also occupied an office on campus. In addition, on several occasions between 1865 and 1867, the South Carolina

Historic Bethel AME Church, Sumter Street, 2014. After worshipping in several locations, the church acquired property on Sumter Street. John Anderson Lankford, one of the first registered African American architects, designed this building. Completed in 1921, this structure housed the church until 1995. That year, the congregation moved to larger facilities, the former site of Shandon Baptist Church, on Woodrow Street. *Photograph by Terry L. Helsley.*

House of Representatives met in Rutledge College on the Horseshoe. In November 1865, the state also held the inauguration of Governor Orr there. The South Carolina Senate met in the basement of Commencement Hall. Later, the Senate held its sessions in the college library.[49]

Among many unresolved issues at war's end was the fate of South Carolina College. Closed when all its students enlisted, the school's remaining faculty members were eager for the school to reopen. Provisional Governor Benjamin F. Perry and his successor, James L. Orr, favored reopening the college. Orr pushed to reorganize the school on the model of the University of Virginia, his alma mater. In December 1865, the legislature authorized the reopening of the college with eight departments and eight professors but with no funding for building repair and greatly reduced faculty salaries. The college reopened in January 1866.[50] For many years, the school struggled with inadequate funding and meager resources.

In the months following Appomattox, South Carolina leaders worked to reestablish order and to reestablish South Carolina's position in the Union.

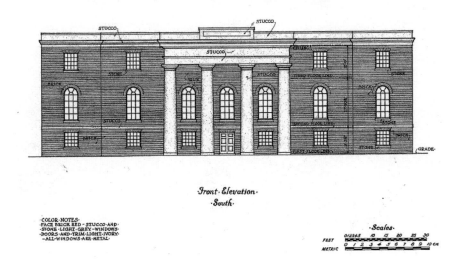

Drawing of the façade, South Caroliniana Library, Historic American Buildings Survey. HABS SC, 40—COLUMB, 2A. *Courtesy of Library of Congress, Prints & Photographs Division.*

President Andrew Johnson appointed a former Unionist, Benjamin R. Perry, as provisional governor. As the state was occupied by Union troops, the South Carolina legislature did not meet in 1867.

In September 1868, Wade Hampton, F.W. McMaster, Joseph Daniel Pope and W.B. Stanley invited John Quincy Adams to visit Columbia. Hampton and associates requested that Adams address a public meeting. Adams accepted the invitation and addressed the group in Carolina Hall. Adams noted "the dangers which threaten our system of government." In conclusion, he added that he would be "amply rewarded" if "by any chance, I may have turned one heart to a calm, patient, earnest, honest effort to forward, so far as in it lies, the restoration of the Constitution and the Union."[51]

Columbia lost much to fire, and residents faced a very different world order. In addition, educational institutions also faced challenges during the postwar years. A victim of the Civil War, Columbia College closed in the postwar years and did not reopen until 1873. Years later, the college acquired property in Eau Claire and in 1905 moved to its new campus.

CONSTITUTIONAL CONVENTION OF 1868

As white South Carolinians boycotted the election, the delegates to the Constitutional Convention of 1868 were black Republicans and white scalawags and carpetbaggers. Members of the convention worked quickly and drew up the state's most progressive constitution. The constitution replaced districts with counties, created the South Carolina Department of

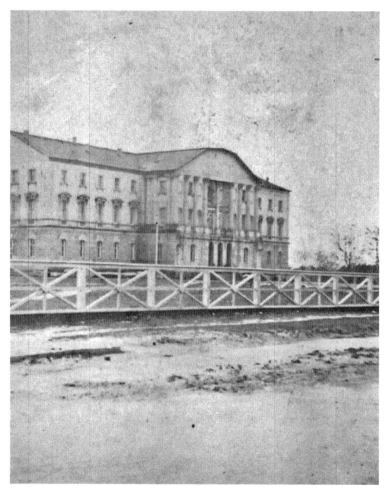

The new statehouse, with a temporary roof. The unfinished statehouse survived the fire that destroyed the original statehouse. Architect Niernsee supervised the installation of a temporary tin roof and the construction of a fence around the grounds. W.A. Reckling, photographer, circa 1867–68. Picture file 900051. *Courtesy of South Carolina Department of Archives and History.*

Education and established home rule. The Constitution of 1868 vacated all offices and called for new elections.

Under the new constitution, the General Assembly elected USC's first black trustees. Between 1873 and 1877, the university was the only southern state university, according to Henry Lesesne, that awarded black students degrees during Reconstruction. The first and perhaps most important black faculty member was Richard Greener. Greener, the first black graduate of Harvard University, earned a law degree from the University of South Carolina. Hired as a professor of mental and moral philosophy, Greener also catalogued the university library.[52]

WILLIAM BEVERLY NASH

Considered "one of the most influential black political leaders of Richland County," William Beverly Nash had a "rags to riches" life. Born a slave in Virginia before the Civil War, Nash worked at Hunt's Hotel in Columbia. With emancipation, Nash, Joseph Taylor and Henry Green owned and operated W.B. Nash Company, a brickyard on Laurel and Assembly Streets. Nash also invested in real estate, and at his death in 1888, he owned five town lots and twenty-six acres on Wheeler Hill. In addition, Nash was a member of Bethel African American Episcopal Church of Columbia.

Nash held a number of political offices. For example, he represented Richland County in the Constitutional Convention of 1868 and also served as vice-president of the convention. Nash also served as magistrate for Columbia and a trial justice. His most influential service was in the South Carolina State Senate. He represented Richland County in several legislative sessions from 1868 to 1878. A highly intelligent man, both Republicans and Democrats respected his abilities. In fact, Nash was considered "the leading man of the Republican party in [the Senate].... He is apparently consulted more and appealed to more, in the business of the body, than any man in it. It is admitted by his white opposition colleagues that he has more natural ability than half the white men in the Senate."

The 1876 election of Wade Hampton and his Redeemers altered the climate in South Carolina for black political figures and black voters. Even the well-respected Nash was not immune. Accused of fraud, W.B. Nash resigned from the South Carolina Senate and repaid the money allegedly misspent.[53]

According to Dr. C.A. Johnson, other important postwar black leaders included Richard Young, who was elected an alderman, and Joe Randals. Randals, who lived on Assembly Street, was a musician and bandleader. C.R. Carrol served as superintendent of education. In addition to W.B. Nash, two other black Columbians—Charles M. Wilder and S.B. Thompson—also served in the Constitutional Convention of 1868. Wilder also served as postmaster. By 1870, Columbia had a population of 9,298.

RANDOLPH CEMETERY

In 1871, nineteen black civic leaders created the Randolph Cemetery Association and organized Randolph Cemetery as a burying place for Columbia's black residents. State Senator William Beverly Nash was the first president of the association. Other members of the original

Historical marker. Randolph Cemetery, established in 1871, is one of the oldest African American cemeteries in Columbia. Notably, in addition to State Senator Randolph, eight other South Carolina Reconstruction-era legislators are buried here. *Photograph by Terry L. Helsley.*

Randolph Cemetery. Prominent African American leaders such as George Elmore, Lucius Wimbush and William Beverly Nash are buried here. The cemetery's name honors South Carolina state senator Benjamin Franklin Randolph, victim of a political assassination in 1868. State Senator W.B. Nash was the first president of the cemetery association. The cemetery was listed on the National Register of Historic Places in 1995. *Photograph by Terry L. Helsley.*

association were Benjamin Thompson, Charles Wilder, Captain J. Carroll, Isaac Blacks, John H. Bryant, Adam Thomas, N.E. Edwards, Augustus Cooper, William Simons, Alonzo Resse, Addison Richardson, J.J. Ransier, Francis L. Cardoza, Robert B. Elliott, John Fitzsimmons, Hampton Mims, W.A. Taylor and C.B. Thompson. Organizers included black businessmen, legislators and Secretary of State Francis L. Cardoza, the first African American to hold statewide elected office in the state. The cemetery's name honors State Senator Benjamin Franklin Randolph, whose 1868 murder was a political assassination.

The Reconstruction years were ones of commercial revitalization, as businesses rebuilt along the burned-out Main Street and new ones opened. The University of South Carolina had an integrated faculty and student body. As a result, white faculty members resigned.

"MISSES ROLLIN"

The vivacious Rollin sisters enlivened the Columbia social scene. Their salon was the political and social sine qua non for aspiring politicians. The Rollin family descended from Haitian refugees who settled in Charleston. After the Civil War, the family moved to Columbia. There, the Rollin sisters attracted considerable attention. Although there were five sisters, in 1868, one sister, Frances Anne Rollin, married William J. Whipper, an attorney and legislator from Beaufort County. The other four unmarried sisters—Katherine, Charlotte, Louisa and Florence—entertained political figures at their salon, known as the "Republican headquarters of South Carolina." So widespread was their fame that in 1871, journalists from *The Sun* and the *New York Herald* visited Columbia, interviewed them and published the interviews. The sisters were well educated and knowledgeable of political affairs, and three were activists and suffragettes. For example, in 1869, Louisa addressed

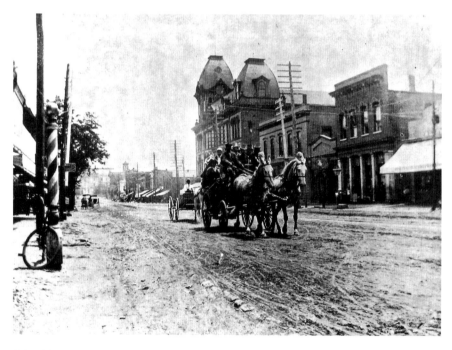

Columbia's second city hall, Main and Washington Streets. Built in 1874, the building replaced the city hall destroyed by fire in 1865. Ironically, in 1899, this city hall also burned. This scene shows Columbia's unpaved Main Street and horse-drawn transport. Samuel Latimer Papers, 22-970, from a copy. *Courtesy of South Caroliniana Library, University of South Carolina, Columbia, South Carolina.*

the South Carolina House of Representatives seeking support for women's suffrage, and in 1870, Charlotte Rollin served as secretary of the South Carolina Woman's Rights Association.[54]

During the 1870s, city officials and residents rebuilt. In 1874, the city built its second city hall. The city hall stood at the intersection of Main and Washington Streets. Ironically, in 1899, this city hall also burned down.

REDEMPTION

[A] *faint fragrance of romance…*
 —Claude G. Bowers

The election of 1876 was hard fought and rife with fraud and intimidation. In October 1876, in an attempt to guarantee a quiet election, General Winfield Scott Hancock ordered federal troops to South Carolina and other southern states. Unfortunately, the troops only guarded the voting sites and so could not address issues of voter intimidation, off-site violence and voter fraud—all of which plagued the election in South Carolina.

The Republican candidate for lieutenant governor prevailed, and the Republican Party maintained control of the South Carolina Senate. The gubernatorial contest was a different situation, and both the Democrats and Republicans claimed control of the House of Representatives. Each party's representatives organized for business and elected its own speakers: General William H. Wallace of Union County (Democrat) and Edmund W.M. Mackey of Charleston (Republican). For an anxious, unsettled time, Columbia was the scene of dueling houses—the Wallace House and the Mackey House. The Wallace House organized with fifty-nine members, while the Mackey House had fifty-seven members. Under the leadership of General Wade Hampton, the Democratic representatives withdrew to Carolina House, while Republicans retained possession of the statehouse chamber.

An even greater challenge was the gubernatorial contest. In 1876, the white elite organized to reclaim control of state government. The Democrats—or

Redeemers, as they styled themselves—chose former Confederate general Wade Hampton III as their candidate for governor. The Republican candidate was Daniel H. Chamberlain, a reform-minded Republican who was running for reelection. Both parties mounted get-out-the-vote campaigns. Neither side wanted to leave the outcome to chance. Fearing a high voter turnout among African American voters, Red Shirts and other paramilitary groups threatened voters. Both sides engaged in ballot box stuffing, and the Democrat/Redeemer party often successfully cast more votes than a given precinct had registered voters. The outcome of the election was uncertain. The State Board of Canvassers certified the Republican candidates, while the South Carolina Supreme Court awarded the election to the Democrats and recognized the Wallace House as legitimate.

Eventually, national politics resolved South Carolina's dilemma. In the contested presidential election of 1876, neither of the presidential candidates won a sufficient number of electoral votes to be elected. The Republican candidate was Rutherford B. Hayes, and the Democratic candidate was Samuel J. Tilden. Tilden won the popular vote but was one vote short of an electoral majority. Hayes, on the other hand, needed twenty electoral votes to win the presidency. Hence, the twenty contested electoral votes were critically important. One of the contested votes was from Oregon, but the other nineteen belonged to "unreconstructed" southern states—Florida, Louisiana and South Carolina.

While Republicans still controlled the election boards in those states, Democratic candidates—through fraud and violence—had won the elections. Both parties claimed victory, and both Chamberlain and Hampton visited Washington and called on the presidential candidates. The conflict lasted for months. Eventually, the United States Congress established a special electoral commission to decide the matter. In the end, the commission had seven Republican members and six Democratic ones. The members voted party lines and announced the election of Rutherford B. Hayes.

After his inauguration, on April 10, 1877, Hayes removed the last United States military forces from South Carolina. Reconstruction in South Carolina ended. Chamberlain surrendered his claim and left the South Carolina Statehouse. Hampton and his supporters triumphantly occupied government offices and the house. Shortly thereafter, the Democrats whittled away at the Republican majority in the Senate and seized complete control of state government.

With the election of Wade Hampton, officials closed USC in order to restructure the school. When it reopened in 1880, the institution, now

Bull Street, Columbia, 1963. This photograph illustrates one of Columbia's famed tree-lined streets. Bull Street runs north–south. South Carolina Department of Transportation, S233002. *Courtesy of South Carolina Department of Archives and History.*

only open to white students, was known as the South Carolina College of Agriculture and Mechanics. For many years, USC faced reorganizations and an uphill struggle to regain legislative support, reclaim the school's prewar reputation and rebuild enrollment.

In 1870, Robert Somers, a Scotsman and newspaper editor, visited the American South. In 1871, Somers published *The Southern States Since the War*. Somers arrived in Columbia during the state fair. He commented on the "country people" who filled the hotels and the status of Columbia's rebuilding since the 1865 fire. According to Somers, the unfinished statehouse was "almost the only building that was spared," as it was "fireproof" or "impervious to flames." But residents had built many "fine brick houses" since the end of the war. Clearly impressed, Somers wrote about "a stately building on an eminence which was clearly the Capitol" and the "magnificent outlines of streets, sweeping spaciously for miles over the heights and hollows of that rich landscape, having rows of fine old trees on either side, and intersected by other wooded avenues equally broad and long, opening up in all directions the most delightful vistas!"[55]

OLD AND NEW

Columbia is a city of such "magnificent distances."
—*Robert Somers, circa 1870*

The Redeemers, or Bourbons, pursued a limited vision for South Carolina. Their goal was to restore South Carolina's prewar governing elite—in other words, restore the antebellum status quo. In 1876, voters supported this limited approach to state government, but cracks in the united white front quickly materialized. Even at the time of his election, Wade Hampton was at odds with extreme elements within the Democratic Party who viewed Hampton as too moderate on racial issues. During his gubernatorial campaign, Hampton had appealed to black voters for support. When he won by a narrow margin, he publicly credited the support of those voters as key to his success. Hampton also appointed a limited number of African Americans to public positions.

John Martin Gary, the leader of the opposition, was from Edgefield and had served in the South Carolina legislature. He supported white rifle clubs and helped organize the Red Shirt campaign that used threats and violence to limit black voter participation in the 1876 election. The Gary faction also stuffed ballot boxes and committed election fraud. With Hampton's election, though, Gary worked hard to derail Hampton initiatives and create a harder line on African American civil rights. As a result, in 1882, the Bourbon-controlled legislature enacted the first serious limitation on black suffrage: the "Eight Box Law," sponsored by Edward McCrady,

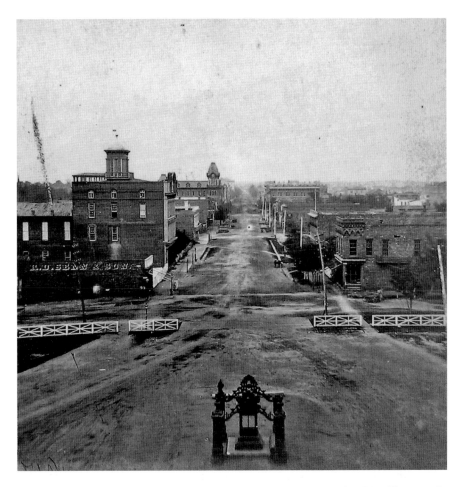

Main Street looking north from the capitol. W.A. Reckling, stereograph, 1870s. Photographs 12932. *Courtesy of South Caroliniana Library, University of South Carolina.*

former Confederate officer and historian, who represented Charleston. The Eight Box Law was an attempt to use literacy to limit black voting. The law specified a separate box for each office. Voters then had to read the box label in order to know where to place their ballots. Any ballot placed in the wrong box was rejected. Although challenged in court, the United States Circuit Court of Appeals ultimately upheld the legislation.

The 1880s were years of reduced political participation for the state's black residents and greater de facto segregation of the races. Columbia's black citizens organized their own churches—for example, Bethel AME (organized in 1866) and First Nazareth Baptist Church (organized in

December 1877 and chartered in 1885). Nevertheless, in Columbia, black and white citizens continued to frequent the same ice cream parlors, theaters and shopping areas.

The Jim Crow years were challenging for the city's African Americans. And white South Carolinians continued to mourn the "Lost Cause." Women organized in societies of remembrance and sponsored monuments to

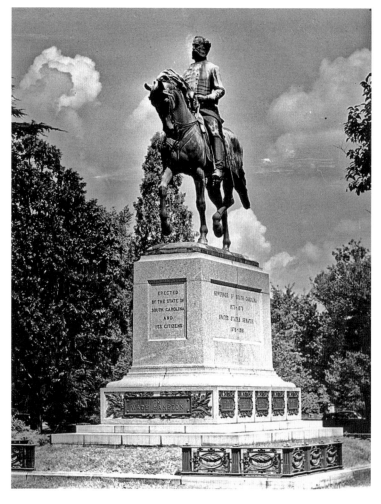

Statue of General Wade Hampton, statehouse grounds. F.W. Ruckstuhl designed this bronze equestrian statue of Wade Hampton III, Civil War general, South Carolina governor and United States senator. In 1891, Hampton spoke at the Centennial Celebration of the South Carolina legislature's first meeting in the new capital. South Carolina Department of Transportation, S233002. *Courtesy of South Carolina Department of Archives and History.*

honor the fallen. On November 4, 1869, women in Columbia organized the South Carolina Monument Association in order to erect a monument honoring South Carolina's Confederate dead. As Radical Republicans controlled the statehouse, the women first tried to locate a site for the statue in Sidney Park, but the ground was not suitable. Then they had the parts of the monument delivered to Elmwood Cemetery. Finally, in 1876, with the election of Wade Hampton as governor, the state paid to move and install the monument on the statehouse grounds. On May 13, 1879, veterans and citizens attended the unveiling. In 1882, a bolt of lightning hit the statue, and the body of the soldier crashed to the ground. Consequently, a new statue was ordered and installed in 1884.

A number of other monuments in Columbia, the state's capital, honor Confederates. For example, shortly after the death of General Wade Hampton, members of the Wade Hampton Camp, United Confederate Veterans, created a committee to erect an equestrian statue of the general. In 1903, Governor Duncan C. Heyward authorized funds for the project. As a result, in 1904, the Hampton Monument Commission selected F. Wellington Ruckstuhl as the sculptor. On November 20, 1906, with considerable pomp, the state accepted the monument and dedicated the statue.[56]

Governor's Heyward's son, Zan Heyward, remembered Confederate veteran reunions on the statehouse grounds. As a child, he liked to wander from one gray-clad group to another, listening to their stories.[57] Confederate veterans' reunions, like the monuments, also served to keep memories of the "Lost Cause" alive.

Topsy-Turvy

On the evening of September 5, 1886, an act of nature disturbed urban tranquility. At about 9:00 p.m., an earthquake shook the capital. Dressed for bed, frightened residents ran into the streets, afraid to remain in their homes. Others, such as habitués of Mancke's Saloon, also sought safety in the streets. At Arsenal Hill, the Governor's Mansion, plaster fell and cracked, damaging two rooms. At the nearby home of T.J. Robertson, a framed picture fell and injured a resident. Some residents sought refuge in local churches as chimneys collapsed and bricks fell into the streets. The great Charleston earthquake affected not only Columbia but also areas as dispersed as Bermuda, Massachusetts, Wisconsin, Alabama and Virginia.

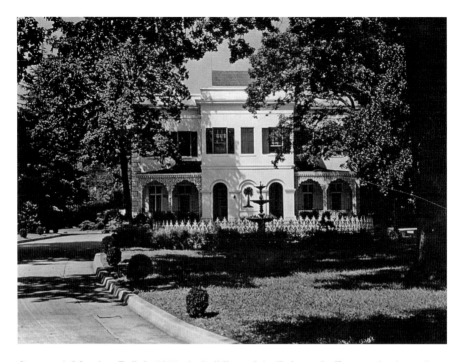

Governor's Mansion. Built in 1855, the building originally housed officers at the Arsenal Academy and was the only school building to survive the burning of Columbia in 1865. South Carolina Department of Transportation, S2330002. *Courtesy of South Carolina Department of Archives and History.*

Columbia was fortunate. Few structures in Charleston were undamaged, and sixty residents died. According to the United States Geological Survey, the Charleston earthquake of 1886 was the most damaging if not the most powerful earthquake to ever strike the southeastern United States.[58]

Although the Constitution of 1868 established public education in South Carolina, the General Assembly did not create the Columbia school district until 1880. Residents elected commissioners who managed the school district. When the district organized, Columbia already had two schools: Sidney Park School (white) and Howard School (black). In June 1883, David Bancroft Johnson became superintendent of the new school district. Although Johnson struggled to fund expenses and pay teachers, he also established the first school library.

Winthrop Normal and Industrial College

In addition, in 1886, the situation changed for South Carolina teachers. On November 15, 1886, Winthrop Training School opened in Columbia with at least nineteen students. The school was the dream of Dr. David Bancroft Johnson, superintendent of Columbia City Schools. Johnson wanted an institution to train teachers for the state's schools. Thanks to his efforts, Robert C. Winthrop, a philanthropist and president of the board of trustees of the Peabody Education Fund, donated the necessary funds to open the teachers' training school. Johnson served as the institution's first president (1886–1928). The school was opened in the carriage house of the Robert Mills House.

In 1891, the South Carolina legislature chartered the Winthrop Normal and Industrial College to educate white women. The goal was to provide an education that was "good enough for the richest and cheap enough for the poorest." To assist with tuition, the state offered scholarships—two per county. Prior to the school's incorporation, Winthrop relocated from Columbia to Rock Hill, where it successfully pursued its goal of educating South Carolina's women and producing teachers for South Carolina's schools.[59]

When Johnson resigned to become president of Winthrop, E.S. Dreher became school superintendent. During his administration, in 1895, the district formally established the city's first high school, Columbia High School, another of Johnson's ideas. Dreher also successfully pushed for the construction of new schools, including McMaster, Taylor and Logan.

Textile Manufacturing

By 1890, Columbia had a population of 15,353. In an effort to attract manufacturing, officials identified the Columbia Canal as a potential power source. Thanks to their efforts, a number of textile mills eventually opened in and around the capital city.

One of these was Columbia Mills, which opened in Columbia in 1894. According to John Hammond Moore, Columbia Mills, now the site of the South Carolina State Museum and the Confederate Relic Room and Military Museum, was the first electric-powered textile mill not only in South Carolina but also the world.[60] In 1891, the nearby Columbia Canal was extended up the Broad River, and the abandoned portion of the canal below Gervais Street was repurposed to produce the electricity to power the plant. By June 11, 1896, the plant was

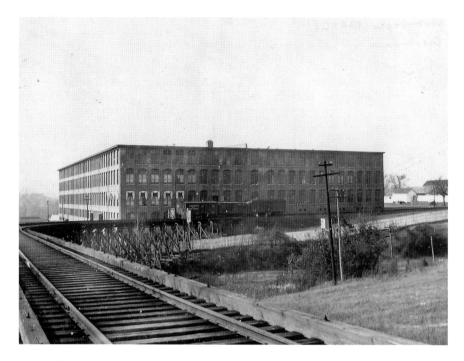

Duck Mill, one of two cotton mills by the river, circa 1899. Built as the Columbia Mills, the building currently houses the South Carolina State Museum. Henry M. King, photographer. Photographs 12050.6. *Courtesy of South Caroliniana Library, University of South Carolina.*

producing the electricity needed to power the adjoining Columbia Mills. The plant also powered the street railway system. As part of South Carolina Electric and Gas (SCE&G), the hydroelectric plant still produces electric power. Today, Riverwalk Park incorporates some of these historic structures, as it follows the shoreline of the Congaree River.

W.B. Smith Whaley, an architect and engineer, was a major factor in developing and building a number of Columbia's mills. The first mill built by Whaley in Columbia was the Richland Cotton Mill, also known as Whaley's Mill. The mill building, completed in 1895, occupies four acres bounded by Main, Catawba, Whaley and Assembly Streets. Unlike much textile construction in the South, the Richland Mill was built by local investors and not with northern capital.

Whaley, a highly respected mill designer, also built the Granby Mill and its adjoining mill village. Completed in 1897, Granby Mill was the first off-site hydroelectric powered textile mill built in South Carolina. The mill village originally had 121 houses for the mill operatives. In 1899, Whaley's firm also built

Olympia Mill on Heyward Street. When opened, Olympia Mill was "the largest cotton mill under one roof in the world." With the addition of three important mills in less than five years, Columbia was on the cutting edge of mill technology. Mill construction provided a much-needed boost to the Columbia economy. But the mills also recruited unemployed agricultural workers to staff their looms and spindles, creating a new type of resident with a different worldview. Many mill operatives lived in tightly knit, highly structured mill villages with initially limited contact with the majority of the city's citizens.

Yet the post-Reconstruction years were also times of positive civic change. For example, by 1893, electric cars were replacing the familiar horse-drawn trolleys. By the First World War, Columbia boasted more than twenty-five miles of track and one hundred trolleys that linked downtown Columbia with its growing suburbs. In 1880, Columbians had telephone service, and in 1887, Columbia switched from gaslights to electric streetlights.[61] Urban amenities were available in the capital city.

In addition, the waning years of the nineteenth century brought other changes. For example, the Columbia Canal powered a variety of mills until the Columbia Water Power Company purchased the canal in 1891. In 1894, the company used power generated by the canal to generate electricity for the new Columbia Mills. In 1903, the city appointed a commission on water and

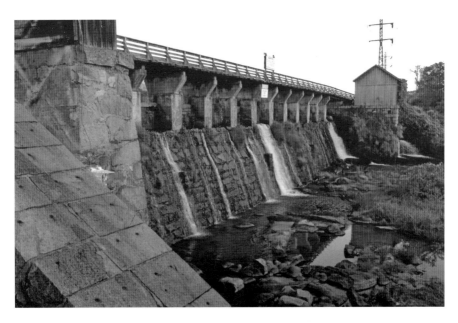

Columbia Canal and Power Plant, Riverfront Park, 2014. *Photograph by Terry L. Helsley.*

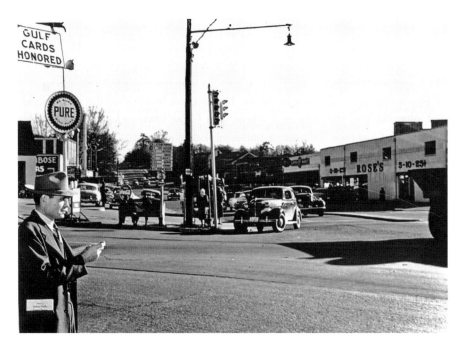

Five Points, Devine Street at Harden Street, circa 1955. Five Points—named for the intersection of Devine, Harden, Saluda, Greene and Blossom Streets—was Columbia's first shopping center. In 1915, to create space for development, the city routed Rock Branch Creek underground. Consequently, flooding continues to plague Five Points merchants. South Carolina Department of Transportation, S233002. *Courtesy of South Carolina Department of Archives and History.*

supporters of Benjamin Ryan Tillman. In 1897, a few years after *The State* printed its first edition, another newspaper, the *Columbia Record*, Columbia's afternoon paper, also began publication.

By 1893, plans were afoot for the first planned development outside the city limits: Shandon. In 1894, the street railway (trolleys) added the new suburb to their routes. Developer Robert Shand named the area "Shandon" to honor his father. Shand also built a pavilion on Devine Street as an entertainment venue. Presaging future problems, the pavilion turned away black customers, catering only to whites.[63]

By the end of the century, deep racial divides plagued Columbia and the state of South Carolina. Jim Crow legislation increasingly defined racial relations as separate but not equal. The law required separate accommodations, separate seating areas in theaters (the balconies) with separate entrances, separate water fountains and restrooms, separate schools and separate seating areas on public transportation—trolleys, buses and rail cars.

WAR AND PEACE

*[A]rrived at Fort Jackson the next morning. The train drew up, not at a station,
but in the open plain. It was a very hot day, and we got out of the train straight
onto the parade ground, which recalled the plains of India in the hot weather.*
—Winston S. Churchill, 1942

The twentieth century dawned with new hope and new dreams. Since
Henry Grady had launched his vision of a "New South," civic leaders
across the South had embraced his new vision for what the South could be.
New South leaders pursued urban enhancements—high-rise developments,
paved streets, water and sewage infrastructure and economic activities. In South
Carolina and the Midlands, textile manufacturing was the hot new economic
opportunity. Granby, Olympia and the other Columbia mills employed
hundreds of operatives, attracting workers from throughout the region and
contributing to the city's prosperity. The city continued to expand beyond its
borders, as residents moved into Wales Garden, Eau Claire and Waverly.

The New South mentality was alive and well in Columbia. Businessmen
Edwin W. Robertson and Frederick H. Hyatt were prime examples. Hyatt
sold insurance and invested in real estate and banking. Robertson owned
the largest bank in the state—the National Loan & Exchange Company—
and built Columbia's first skyscraper to house it. Major investments sparked
other commercial activity in the city's downtown commercial district.

By 1907, officials were paving Columbia's streets. With the Columbia
waterworks and hydro dam, the city already had several legs up on the

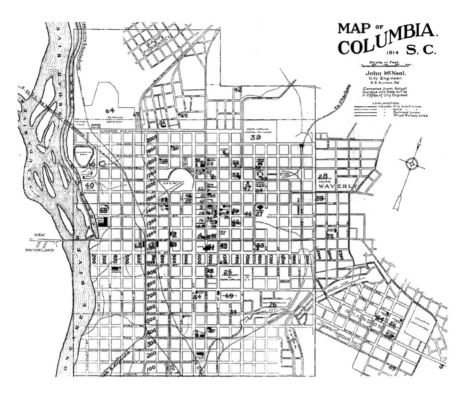

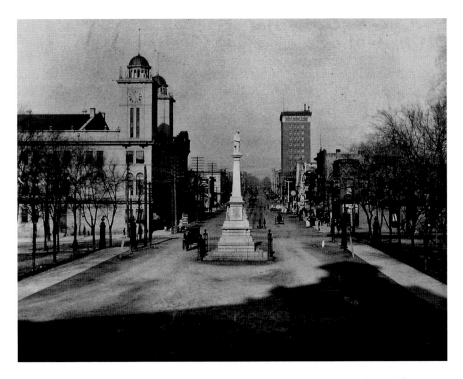

Main Street looking north from the capitol, 1905. In the center, the Confederate Monument gleams. On the left stands city hall, and on the right is the recently constructed Barringer Building (National Loan and Exchange Bank Building), Columbia's first skyscraper, the dream of Columbia businessman Edwin Wales Robertson. *Art Work of Columbia*, Part 1, 1905 (720.9757711 Ar 7). *Courtesy of South Caroliniana Library, University of South Carolina.*

Opposite, top: Map of Columbia, South Carolina, 1914. By 1914, the Palmetto Building stood on Main Street and the new YMCA on Sumter Street. Woodrow Wilson, former resident and then governor of New Jersey, spoke at the laying of the cornerstone. In 1910, the city had 26,318 inhabitants—14,772 white and 11,546 black. Map Collection. *Courtesy of the South Carolina Department of Archives and History.*

Opposite, bottom: South elevation, view of top stories, Palmetto Building, 1400 Main Street at Washington Street. Built in 1913, the Palmetto Building, with its terra-cotta façade, is one of Columbia's architectural treasures. When constructed, the fifteen-story Palmetto Building was the tallest structure in the capital. *Courtesy of the Library of Congress, Prints & Photographs Division.*

New South ladder. New South concerns formed a rapid segue into the Progressive movement. While in South Carolina Progressives worked hard to distance themselves from national organizations and agendas, they did tackle similar issues—education, health, parks and hospitals.

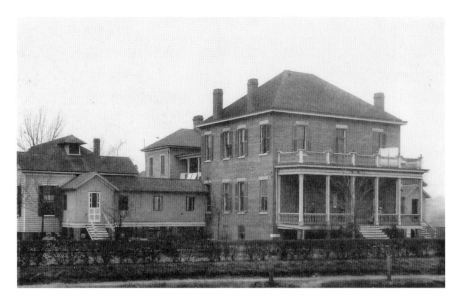

Columbia Hospital, 1905. Established in 1895, Columbia Hospital stood at the corner of Hampton and Harden Streets. *Art Work of Columbia*, 1905, Part 5 (720.9757711 Ar7). *Courtesy of South Caroliniana Library, University of South Carolina.*

Blue Marlin Restaurant, Gervais Street, 2014. Formerly the Seaboard Airline Railway Station, the historic structure is an example of successful adaptive reuse. The Seaboard Airline Railway's motto was "Through the Heart of the South." *Photograph by Terry L. Helsley.*

In South Carolina, concerned women organized to found hospitals and force city fathers to create parks.

During the early twentieth century, healthcare improved. For example, in 1913, women from Trinity Episcopal Church organized South Carolina's first tuberculosis hospital. Earlier in 1892, the King's Daughters organized a hospital. A group of doctors assumed control of the facility in 1909, and by 1913, the county controlled Columbia Hospital. Also, in 1914, Knowlton Infirmary became Baptist Hospital. These facilities assisted white residents. Black Columbians had Good Samaritan and Waverly.

In Columbia, Progressives formed the Civic Improvement League. The league employed a landscape architect to develop a master plan for the city. As a result, Columbia gained four city parks. Unfortunately, one of the gems of the park system was Sidney Park. In 1899, at the behest of railroad executives with the Seaboard Air Line Railroad, city officials agreed to destroy the green gem and permit the railroad to build a terminal there. Possible economic benefits drowned the protests, and Seaboard Park became a reality.

WAVERLY NEIGHBORHOOD

Originally, the Waverly neighborhood was a white subdivision on the outskirts of Columbia. Waverly, along Taylor Street, was one of the early residential developments beyond the city limits. Nevertheless, by the early twentieth century, Waverly was an active black community. Professionals, craftsmen and social activists lived there. The Waverly neighborhood reflects, in microcosm, the racial segregation that the Jim Crow era brought to Columbia in the late nineteenth century.

By 1900, Columbia had a population of 21,108. New suburbs surrounded the original city. Yet by 1913, the city had incorporated most of these areas within the city's ever-expanding city limits. Meanwhile, New South leaders pushed for economic development and enhanced civic amenities. Having experienced the economic impact of a military installation, city leaders lobbied for a permanent facility near the capital.

Freedom of the Press

The conflict between *The State* and Tillman came to a head in 1903. On February 15, Lieutenant Governor James H. Tillman fatefully encountered Narciso Gener Gonzales. Tillman was the nephew of Benjamin Tillman, South Carolina's influential United States senator and former governor. Gonzales, the son of a Cuban revolutionary, was the editor of *The State* newspaper. The lieutenant governor had adjourned the state senate and was walking up Main Street. Gonzales left the newspaper office walking home for lunch. The two men met at the corner of Main and Gervais Streets—one of the busiest spots in downtown Columbia. Tillman pulled a revolver from his pocket and shot the unarmed editor. The wounded editor fell to the pavement, shouting, "Shoot, again, you coward." Gonzales lingered several days in Columbia Hospital before dying of his wounds.

Although Lieutenant Governor Tillman fired several bullets into the editor, a jury in Lexington accepted Tillman's assertion of self-defense and acquitted him. Tillman apparently resented editorials and news reports

Narciso Gener Gonzales House, 1010 Henderson Street, 2014. Gonzales was the crusading first editor of *The State* newspaper. In February 1903, at the corner of Main and Gervais Streets, Lieutenant Governor James Hammond Tillman mortally wounded the unarmed Gonzales. An obelisk at the intersection of Sumter and Senate Streets commemorates Gonzales's life and service to his state. *Photograph by Terry L. Helsley.*

published in *The State*. He was also known for his hot temper and intemperate drinking. But his powerful uncle—United States senator Benjamin Ryan Tillman—marshaled his extensive network of political connections in support of his nephew. He also secured talented legal representation for the younger Tillman. Newspapers in the state and throughout the nation denounced the verdict.

Supporters of Gonzales raised money to erect a special obelisk honoring the editor and his career—one of the few such memorials in the United States. It is said that the monument was placed at the intersection of Sumter and Senate Streets, so Tillman could see it whenever he left the capital building. To W.W. Ball and others, Gonzales was a martyr to freedom of the press.[64]

By 1907, six textile mills were operating in the Greater Columbia area. These mills employed more than 3,400 workers and added millions to the city's annual revenues.

THE REVEREND CHARLES JAGGERS

In 1903, a remarkable man opened a special ministry in the capital city. Reverend Charles Jaggers was a man of great faith who overcame serious challenges in his life. Born a slave in Fairfield County and crippled early in life, Jaggers became a Christian at age fourteen. From that time until his death, Jaggers preached and ministered to the less fortunate. In 1903, with few resources, Jaggers founded the Old Folks' Home on Elmwood Avenue. His wife and daughter took care of the facility and its residents. While Jaggers, according to Works Progress Administration (WPA) interviews, never asked for money, he did extend his hat, and the community responded. Donations of goods, money and professional services supported and maintained Jaggers's ministry.

After a long life of service, Reverend Jaggers, at ninety-five years old, died in 1925. The mayor of Columbia issued a proclamation honoring Jaggers and his life. Business ceased, the country court adjourned and black and white residents gathered to mourn the passing of one whose life made Columbia a better place.

In 1908, the state legislature also addressed the issue of care for the aged and infirm. It established a Confederate soldiers' home on Confederate Avenue at Bull Street. The Confederate Home and Infirmary opened on May 10, 1909 (Confederate Memorial Day). The facility provided a home

for indigent and infirm veterans from every county. As the number of needy veterans dwindled, in 1925 the home accepted wives and widows and, eventually, daughters and nieces of Confederate veterans. The home closed in 1958, but for decades, it provided a much-needed safety net for the state's Confederate veterans and their families.

TAFT ON TOUR

In 1909, Columbia had another notable visitor. In November 1909, President William Howard Taft stopped in Columbia during a tour of the United States. According to *The State*, Taft's visit was the first time a president had visited the capital city in more than one hundred years. Taft addressed residents at the fairgrounds and then lunched at the statehouse.[65] While Taft and state leaders lunched in the chamber of the House of Representatives, women observed from the galleries.[66]

In 1910, the legislature provided matching funds for school construction in South Carolina. As a result, Columbia used this opportunity to build two new schools: Logan School and Columbia High School. Other early twentieth-century educational opportunities included the Lutheran Seminary, which moved to Columbia in 1911, and Draughon's Practical Business College, which operated during the 1920s and offered clerical training for Columbia residents.

PRESIDENT WOODROW WILSON

Change was in the air. In 1913, former resident Thomas Woodrow Wilson became the twenty-eighth president. Wilson lived several years (1870–74) in Columbia after his father, Dr. Joseph Ruggles Wilson, joined the faculty of the Presbyterian Theological Seminary. Young Wilson was fourteen when his family moved to the capital. Dr. Wilson also preached at the First Presbyterian Church in Columbia.

The Columbia years were important ones for the future president. His sister married Dr. George Howe, son of another Presbyterian seminary professor, in 1874, and both his parents and his sister are buried in the churchyard of the First Presbyterian Church. The Columbia house

Woodrow Wilson Boyhood Home (built in 1871), Hampton Street, 2014. The future president lived in this house during his teen years. Offered a position with the Presbyterian seminary, Wilson's father left his pastorate in Augusta and moved to Columbia. According to the Historic Columbia Foundation, the "Wilson home is South Carolina's only presidential site." The house barely escaped demolition in 1928. Supporters saved the house, and in 1932, it was opened as a house museum. *Photograph by Terry L. Helsley.*

on Hampton Street is the only home the Wilson family ever owned. Perhaps more importantly for "Tommy" Wilson, it was during his time in Columbia that he experienced a religious conversion and united with the First Presbyterian Church. It was also in Columbia that young Wilson met the president of Princeton. According to Wilson biographer Scott Berg, James McCosh, president of Princeton, visited Dr. Wilson. During that visit, McCosh encouraged Woodrow Wilson to apply to Princeton. Wilson's years at Princeton as student and, later, president were essential for his political future. As president of Princeton, voters elected Wilson governor of New Jersey, an essential steppingstone to the White House. Spending his formative years in Reconstruction-era Columbia also shaped the future president's worldview.

President Wilson's uncle, James Woodrow, also taught at the Presbyterian seminary. Unfortunately, Woodrow's views on creation and evolution polarized the faculty and seminary supporters. Consequently, in 1886, Woodrow's connection with the seminary ended. Professor Woodrow then

joined the faculty of the University of South Carolina and between 1891 and 1897 also served as president of the university.

The Columbia Theological Seminary, founded in Georgia in 1828, relocated to Columbia in 1830. In Columbia, the seminary occupied Ainsley Hall (also known as the Robert Mills House) on the block formed by Taylor, Henderson,

President Woodrow Wilson with his wife, Edith Bolling Galt, circa 1919. During his teenage years, Wilson lived in Columbia, where his father taught at the Presbyterian Theological Seminary. LC-USZ62-32695. *Courtesy of Library of Congress, Prints & Photographs Division.*

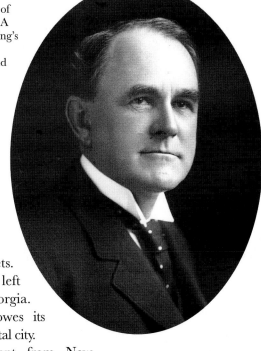

Governor Richard I. Manning III (1859–1931). Manning served as governor of South Carolina from 1915 to 1919. A Progressive governor, during Manning's administration the state enacted compulsory education legislation and raised the minimum age for child labor to fourteen. As the state's governor during World War I, Manning was a strong supporter of President Woodrow Wilson. Manning, a native of Sumter County, died in Columbia in 1931. Picture file 900051. *Courtesy of South Carolina Department of Archives and History.*

Blanding and Pickens Streets. In 1927, the seminary left Columbia for Decatur, Georgia. However, the institution owes its name to its sojourn in the capital city.

Although elected president from New Jersey, Wilson never forgot his southern roots, and consequently, Columbia and South Carolina leaders maintained close connections with the Wilson White House. Elected as a Progressive and then reelected with the campaign slogan, "He kept us out of war," Wilson faced a daunting task as conflict broke out in Europe. With the coming of World War I, the United States Army established Camp Jackson, then on the outskirts of Columbia. Columbia investors purchased the land for the military base.

During these difficult years, Richard I. Manning was the governor of South Carolina. Manning was the state's most progressive governor. Under Manning's administration, the state adopted educational and child labor reforms. Manning and other civic leaders joined with Wilson to support the war effort. In addition to war-related activities, Manning also organized the South Carolina State Council of Defense to provide support on the homefront. As a result, the council worked to suppress dissent. For example, even though Ben L. Abney was Columbia counsel for the Southern Railroad, suspicion cost him his position. Accusers charged that Abney did not support the Red Cross.

WORLD WAR I

During the war, Camp Jackson became the largest army cantonment in the country, and Columbia became a major military center. On September 1, 1917, the first recruits arrived at Camp Jackson. The camp had an airfield and a training school for officers. In August 1918, the United States drafted 130,207 men. White draftees assigned to Camp Jackson were southerners who hailed from Florida, North Carolina and South Carolina. In addition, black trainees from South Carolina and Georgia were also assigned to Camp Jackson. Nevertheless, black and white recruits had separate facilities.

In addition to the increased military presence, Columbia's city leaders faced other issues. For example, war authorities challenged the city's former laissez-faire attitude toward prostitution. At the outbreak of war, Columbia had licensed houses of prostitution in a vibrant red-light district located between Gates, College, Wheat, Senate, Lincoln and Pendleton Streets. In

Section of Camp Jackson, circa 1916. During World War I, soldiers trained at Camp Jackson, officially known as the Sixth National Army Cantonment. John Allen Sargeant, photographer. LC-USZ62-124483. *Courtesy of Library of Congress, Prints & Photographs Division.*

time, the city reluctantly agreed to federal demands. Closing the houses and relocating the madams and their employees had social and economic effects on the city and its residents.

In camp, Athletic Director F.M. Dobson, a former college coach, coordinated sports offerings for the Young Men's Christian Association (YMCA). Dobson organized baseball, football and basketball leagues and interleague play. During September 1918, for example, 238,457 soldiers viewed these athletic contests. Baseball, the all-American sport, attracted the largest crowds. Camp Jackson had 2,145 men playing baseball on 145 teams in sixteen leagues. At the time, Camp Jackson was a Field Artillery Replacement Depot.[67] In addition to intramural and league games (for example, between the Charlestown, Massachusetts team and the Eighty-first Division team from Camp Jackson), there were also major-league exhibition games. Generally, these exhibition games benefited the War Camp Recreation Fund. Teams such as the Boston Braves, New York Yankees, Washington Senators and Philadelphia Phillies competed in these benefit games. In 1918, the camp was particularly excited to welcome Clark Griffith, manager of the Washington team. Griffith organized and supported efforts to provide baseball equipment for United States military forces, whether in training or deployed overseas.[68]

Influenza Pandemic

While service in World War I was hazardous to United States doughboys, the homefront also had its threats. Disease was a major one. The war years saw a major outbreak of Spanish influenza. The first cases appeared in South Carolina in 1918. At the time, Columbia had only two hospitals—Columbia and Baptist—with fewer than 150 total beds available. Flu cases quickly overwhelmed the city's health facilities. In an effort to contain the contagion, officials closed the city's public schools in October. The South Carolina Supreme Court and Richland County Court of Common Pleas were also closed. Pacific Mills, an area textile plant, organized food delivery for its homebound workers.

As Columbia was a segregated city, healthcare was also segregated. Even the Red Cross had white and black organizations. On the campus of the university, sick students quickly filled the infirmary. College administrators designated several buildings as temporary hospitals for afflicted patients.

As a result of the outbreak, the sale of patent medicines that promised to relieve flu symptoms proliferated, and under pressure, the governor released contraband alcohol. In 1916, South Carolina had adopted statewide prohibition, three years before the United States outlawed the sale of alcoholic beverages.

Matters at Camp Jackson were serious. The 1918 influenza strain particularly targeted young adults. Consequently, the situation at military bases quickly deteriorated. Also, by the time the flu arrived, Camp Jackson had already weathered outbreaks of measles and meningitis. As hundreds of soldiers fell ill, the base hospital was quickly overwhelmed. Then thousands fell ill, and much of the camp served as an impromptu hospital. Of the five thousand stricken with influenza, at least three hundred died. Fortunately, by the summer of 1919, the crisis had passed.[69] Concerning deaths on base, James C. Dozier had an interesting memory. As a boy, he remembered exploring the base and finding a "huge earthen mound" with a heavy steel door. When he and his friends opened the heavy door, they found a poorly lit, "gloomy and scary interior." The chamber contained hundreds of "wooden racks from the floor to the ceiling," Each rack held a large steel tray. The scared boys ran to the Dozier home. Later, Dozier's father (who was South Carolina's adjutant general), explained that the bunker housed the bodies of flu victims until they could be shipped home.[70]

ARMISTICE DAY

On the eleventh hour (Paris time) of the eleventh day of the eleventh month, in 1918, Allied and Axis powers signed an armistice officially ending the Great War. At that historic moment, sometime Columbia resident Zan Heyward was on a troop train en route to the front. Writing for the *Columbia Record*, Heyward vividly recalled the "the low grumble of big guns as they spoke their message of death," and "then, suddenly, there was silence." The young soldiers disembarked from the train and celebrated with two elderly Belgium refugees. As Heyward noted, they drank cognac from a "cob-web covered bottle," and while the ladies danced on the table, they sang "The Star-Spangled Banner" and "every verse of *Mademoiselle from Armentieres*."[71]

The "War to End All Wars" ended, and the service men and women returned home. To honor those who did not, the workers at Pacific Mills erected a statue in Olympia. The bronze doughboy honors "the memory

of our comrades who gave their lives in the World War." E.M. Viquesney created the sculpture *The Spirit of the American Doughboy*. Four men—Fred B. Spigner, W.R. Connelly, John H. Nickhols and John J. Lever—spearheaded the effort, and millworkers at the Pacific Mills Plant raised the money to purchase the statue. The monument was dedicated on November 11, 1930, and includes the Pacific Community honor roll—a list of 224 names.

The end of the war was not the end of Camp Jackson. But the postwar years were times of change for the camp. By April 1923, only seventeen soldiers garrisoned the camp. That month, arsonists set several fires that destroyed eight barracks, nine other buildings and the first brigade hotel. As a result, Captain John Faucette, the camp's commander, closed Wild Cat Road, the main route through the camp, to civilian traffic.[72]

In 1925, federal authorities transferred the deactivated facility to the South Carolina National Guard. During the 1930s, the family of Colonel James C. Dozier lived on the base. Colonel Dozier's father, Brigadier General James C. Dozier, was a Medal of Honor recipient and South Carolina's adjutant general (1926–59). As adjutant general, he had command of the South Carolina National Guard and, at the request of the United States War Department, Camp Jackson. Writing later, Dozier recalled the "exhilarating" experience of living on a "military reservation" with a pool and a lake. In the summer, the National Guard trained at the base, and one year in the depths of the Great Depression, the War Department housed thousands of homeless men at the camp. According to Dozier, one year the Clemson football team trained at Camp Jackson before the big Clemson-Carolina game.[73]

In 1925, Columbia had 41,225 residents. The city was not only the center of state government but also a state leader in hydroelectric power, education and manufacturing. True to its early roots and central location, the city was a transportation nexus for rail and road travel. In 1928, the Gervais Street Bridge opened over the Congaree River. Although the Depression affected economic opportunities, the city's population continued to grow, and by 1930, 65,000 called Columbia home. Yet social and economic inequalities persisted. Economic, educational and healthcare opportunities for Columbia millworkers and black citizens were limited.

Beginning in 1926, the Palmetto Leader Publishing Company published the *Palmetto Leader*, a newspaper for the city's black residents. Editor N.J. Frederick pushed self-improvement, but George A. Hampton, a later editor, pushed for civil rights and improved employment possibilities. In addition, during its years of publication (1926–44), the newspaper attacked the evils of

Gervais Street Bridge, 1972. This bridge over the Congaree River connects Columbia and West Columbia. On June 28, 1928, the bridge was opened for traffic. South Carolina Department of Transportation, S233002. *Courtesy of South Carolina Department of Archives and History.*

lynching and opposed the white primary and, during the war years, segregation in the armed services. Yet, on March 28, 1936, an article on Columbia's 150th anniversary noted, "No city of the South has a better record for fair and just treatment of the weaker element than Columbia, and as a result the race relation is and has always been of the best."[74]

DEPRESSION AND NEW DEAL

Black Thursday in 1929 not only sent the stock market crashing but also aggravated the state's agricultural depression and deepened South Carolina's manufacturing difficulties. Between 1929 and 1932, salaries, jobs and days of operation declined for mills in Columbia and statewide. By 1932, unemployment in Columbia was twelve times higher than in 1929. Statewide, annual income declined from $261 to $151. The state paid schoolteachers with scrip and not money. With fewer jobs and dramatically less income for those with jobs, more Columbians faced hunger. For example, in 1931, private relief organizations in the city served more than 700,000 meals to Columbia's neediest residents. In the 1930s, Columbia was a city of sixty thousand people. At least twelve thousand were unemployed, and of that number, one hundred souls lived at the "city dump." Many "scrounged for scraps of food and lived in abandoned automobiles or shipping crates."

With such need, many South Carolina leaders avidly supported Franklin D. Roosevelt's campaign for the presidency. One early supporter was Claud A. Sapp, chair of the South Carolina Democratic Party. Sapp organized Roosevelt Southern clubs, and by March 1932, he had been named South Carolina campaign director for FDR. Roosevelt won the election, and after his inauguration, in an attempt to deal with the country's economic woes, he launched a number of New Deal programs. In June 1933, Governor Ibra C. Blackwood appointed Columbia's Malcolm Miller as director of South Carolina Emergency Relief Administration (SCERA).

Yet SCERA attracted severe criticism, and in June 1934, almost two thousand unemployed rallied at the Columbia Township Auditorium. They protested the politicization of relief distribution. When little changed, Columbia resident Ben E. Adams, editor of the *Carolina Free Press*, organized a statewide protest. Protestors booed the governor and Miller. As the protests continued and escalated, a federal investigation found widespread difficulties.

More successful were Works Progress Administration (WPA) efforts to improve roads and highways and the South Carolina Art Project, which developed an art gallery in Columbia and sponsored art education in the schools. Columbia merchants unanimously supported the National Industrial Recovery Act (NIRA) efforts to improve the climate for business. As W.E. DeLoache of the Columbia Chamber of Commerce stated, "Columbia will cooperate 100 percent on this request or anything that Franklin D. Roosevelt wants."

Yet the textile mill experience was mixed. After July 17, 1933, mills embraced forty-hour workweeks, and mills in Columbia increased payroll. With a twelve-dollar-per-week wage, a family of four in Columbia could eat for three dollars per week and have money left for other needs. Unfortunately, established workers benefited little, as their pay did not rise and mills continued to use the "stretch out" to increase production and keep labor costs low. Workers went on strike, and on July 25, 1933, four hundred workers gathered at Dreyfus Field in Columbia to demonstrate for unionization. Some thought that the NIRA encouraged union membership. Although great worker unrest roiled the state in 1934, Columbia mills escaped the bloody confrontations of the upstate. Columbia workers, though, were involved in efforts to close mills. Columbia had a long history of textile tension and occasional strikes.

Nevertheless, with manufacturing and New Deal programs, Columbia continued to grow. In 1935, with federal assistance, the World War Memorial opened. Originally, Governor Richard Manning had the idea for a memorial honoring the men and women who served in the Great War. In 1919, the South Carolina General Assembly approved the proposal and appropriated construction funds. But the Great Depression intervened, and state funds vanished. So, from 1919 until 1935, the War Memorial Commission worked to garner popular support and raise donations for the project. In 1934, the Public Works Administration, a New Deal program, awarded the state a $33,200 grant, and construction began. When completed, the World War Memorial Building housed the state archives. The archives opened in 1895 with only one staff member. Alexander S. Salley had struggled for many years in the basement of the statehouse. The state's valuable historic records dating from 1671 lacked adequate storage, arrangement and conservation. In 1960, under the direction of Director J. Harold Easterby, the state built a modern archival facility at the corner of Senate and Bull Streets. The new building had temperature- and humidity-controlled storage vaults for the records, as well as a conservation laboratory.

To meet increased demand, in 1936 a new United States District Courthouse opened in Columbia. Built in Renaissance Revival style, the courthouse was constructed with poured concrete, a rare method of building. The United States District Courthouse housed not only the United

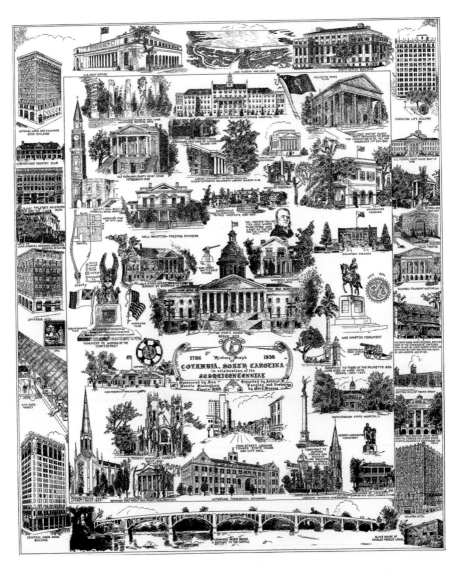

History graph, Columbia's sesquicentennial (1786–1936). The graph, compiled by Arthur H. Langley and drawn by Jack Kneece, illustrated important events and significant sites associated with Columbia's history. Unfortunately, several of the sites, such as the Lafayette House on Gervais Street, no longer stand. Picture file 900051. *Courtesy of South Carolina Department of Archives and History.*

States District Court but also offices of the United States District Attorney. In 1934, the City of Columbia purchased the former federal courthouse to use as a city hall. Located at the corner of Main and Laurel Streets, the historic building is listed on the National Register of Historic Places. Alfred B. Mullett (1834–1890), a well-known federal architect, designed the building, which was constructed of granite quarried in nearby Winnsboro.

In 1936, the city of Columbia celebrated its 150th anniversary. City residents celebrated with balls, plays, parades and concerts. Town Theatre, founded in 1919 and the oldest community theater in the United States, performed Gilbert and Sullivan's *The Pirates of Penzance, or the Slave of Duty*. Helen Kohn Hennig published *Columbia: Capital City of South Carolina, 1786–1936*. The city also gained Sesquicentennial Park.

However, in the depths of the Depression, Columbians found time for recreation. In 1936, investors purchased the former House of Peace Synagogue, erected circa 1907. Converted into an African American nightclub, the Big Apple was a popular entertainment venue. Dancers there developed a popular new dance. The dance craze swept the county, and

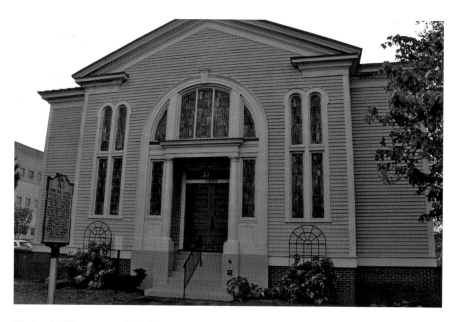

Big Apple, Hampton at Park Streets, 2014. Originally the House of Peace, a Jewish synagogue, in the early twentieth century, this building later housed a black nightclub. Dancers there originated the "Big Apple," a dance craze that eventually—thanks to the Great Migration of black South Carolinians to the North—reached New York City. *Photograph by Terry L. Helsley.*

in 1937, Tommy Dorsey (1905–56), the famous big-band leader, with his Clambake Seven, performed "The Big Apple."

Olin D. Johnston, an ardent pro–New Dealer, became governor of South Carolina in 1935. During his administration, Huey P. Long, a United States senator from Louisiana and an inveterate foe of President Roosevelt, visited Columbia. Long, former governor of Louisiana and a potential presidential candidate, wanted to garner support for his "Share Our Wealth" campaign among textile workers and on college campuses. "Every Man a King" was his motto, as Long campaigned to redistribute wealth and reduce poverty.

As soon as Long's plans were announced, state and university leaders moved to limit the impact of his visit. In the end, denied a forum on campus, Senator Long invited students to a lunch event at the Columbia Hotel on Gervais Street and later spoke from the statehouse grounds. Long's reception was cool and hostile. Long returned to Louisiana, where on September 8, 1935, he was assassinated by a political opponent.

In stark contrast to the Long visit was FDR's visit in 1938. On December 5, Governor Olin D. Johnston entertained President Franklin Roosevelt at the governor's house. According to reports, the governor's staff served only specially prepared South Carolina dishes. Roosevelt also addressed South Carolinians from the steps of the north portico of the statehouse.

Also, the Public Works Administration introduced the concept of "decent housing" to Columbia. A national survey identified more than 32 percent of Columbia's housing as "crowded"—twice the national average. In addition, two-thirds of the housing had electricity, and only 62 percent had "indoor water closets." Columbia's figures were far below the national average. As a result, the PWA awarded two of the agency's first fifty-one low-rent projects to Columbia and Charleston. In August 1935, Harold Ickes initially announced an award of $450,000 to construct housing for African Americans in Columbia. But immediate public outcry forced Ickes to amend the award to include housing for white Columbians as well. The result was the University Terrace project, with segregated units for black and white residents. Later, in 1939, the United States Housing Authority (authorized in 1937) awarded Columbia $1.5 million to build two hundred low-income units at Gonzales Gardens and Calhoun Court.[75]

Efforts to provide low-income housing and reduce urban blight had unanticipated consequences. The precedent later enabled the city and the University of South Carolina to use a similar approach of grants and eminent domain to vacate other black neighborhoods. These efforts changed the face

Governor Richard Riley salutes the American flag during a review of the Citadel Corps on the steps of the statehouse, March 13, 1985. Dignitaries such as William Jennings Bryan in 1900, "Black Jack" Pershing in 1920 and President Franklin D. Roosevelt in 1938 addressed crowds of citizens. Governor Richard Riley Papers, S5554023. *Courtesy of South Carolina Department of Archives and History.*

of Columbia, altered the makeup of historic neighborhoods and affected commercial development in the city and environs.

In 1937, as part of a national campaign to eradicate lynching, the National Association for the Advancement of Colored People (NAACP)

organized a chapter at Benedict College. In February 1937, student chapter members joined other South Carolina students to demonstrate against lynching—one of the first civil rights demonstrations in the state before the outbreak of World War II.

Columbia in 1940

In 1940, the city was in recovery mode, with a population of 51,581. The city boasted three rail stations that served passengers traveling on the Southern, Atlantic Coastline and Seaboard Airline Railroads. In addition, there were ten hotels, including the DeSoto and Jefferson, and five movie theaters, including one just for black patrons. For white Columbians, the highlight of the year was the state fair, with the "Big Thursday" football

Bull Street, Columbia, 1963. This image depicts one of Columbia's famed tree-lined streets. Bull Street runs north–south. South Carolina Department of Transportation, S233002. *Courtesy of South Carolina Department of Archives and History.*

game between state rivals Clemson University and the University of South Carolina. The ritualistic nature of the conflict affected even the state's governor. Traditionally, at halftime and "with great ceremony," he moved his seat from one side of the stadium to the other. The state fair occurred during the third week of October, and the companion Palmetto State Fair for the state's African American residents was held the last week of October. Two radio stations, WIS and WCOS, ensured that residents had the latest news. The Big Thursday tradition ended in 1960. As a result, the annual interstate competition now rotates between Clemson's "Death Valley" and USC's Williams-Brice Stadium.

Columbia was a beautiful city, with "wide, shady streets" and an "atmosphere of space." Oak and elm trees lined the city's broad avenues. Accenting its significance to the city and state, the dome of the statehouse dominated the skyline from all approaches. According to some, when the General Assembly convened, the Japanese magnolias were blooming, and when the *Magnolia grandiflora* bloomed in the spring, the legislators headed home.

Yet not all Columbians lived on broad, paved, tree-lined streets. The city's poorer residents—black and white—lived in wooden shotgun houses, clustered near the jail and state penitentiary on unpaved streets between Columbia's busy commercial area and the river.[76]

WORLD WAR II

Despite high hopes, the "War to End All Wars" did not succeed, and events in Europe and Asia once again embroiled the United States in a world war. When Japanese planes attacked Pearl Harbor on December 7, 1941, the United States was officially again at war.

In 1940, as part of war preparedness, the army reestablished and enlarged its base in Columbia—renamed Fort Jackson. The coming of Fort Jackson as a permanent army base brought population (forty thousand) and cash to the capital city. During World War II, thousands of recruits trained at Fort Jackson. In June 1942, Prime Minister Winston Churchill of Great Britain secretly visited the base. He reviewed troops, watched a parachute demonstration and was clearly pleased with what he saw. Major General Hastings L. Ismay, deputy military secretary in Churchill's war cabinet, was one of several British subjects traveling with Churchill. Henry Stimson, the U.S. secretary of war, and General George C.

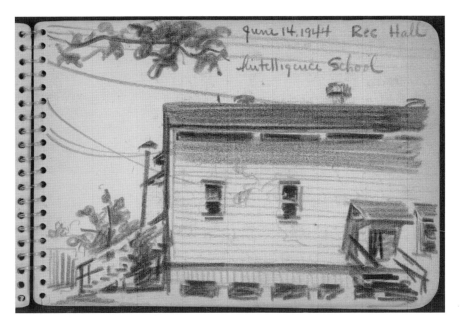

Fort Jackson, Recreation Hall and Intelligence School, June 14, 1944. During World War II, Fort Jackson was a major army troop training facility. Alfred Lundy, artist. *Courtesy of Library of Congress, Prints & Photographs Division.*

Marshall, chief of staff of the U.S. Army, accompanied this distinguished visitor. Major General Robert L. Eichelberger, commanding general of the First Army Corps, greeted the prime minister. Writing later, Churchill commented, "It was a very hot day, and we got out of the train straight onto the parade ground, which recalled the plains of India in the hot weather." Commenting on the parachute demonstration, Churchill found the participants "impressive and convincing." He was also excited about his first encounter with a "walkie-talkie."[77]

Ancillary operations included Columbia Army Air Base (Lexington County) and Congaree Army Air Field in lower Richland County, as well as troops who trained at Owens Field. The military presence became a significant part of Columbia's and Richland County's economies. Khaki-clad soldiers mingled with government workers on the city's busy streets. Hotels were packed; rationing, food scarcities and long lines were the norm. As Banjo Smith noted, "Columbia today…1943…a busy, bustling, seam-splitting city at war."[78]

The influx of population exceeded available rental space and brought issues of price gouging and substandard accommodations. Troops on leave

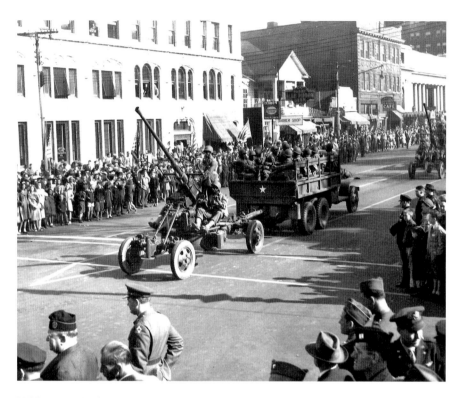

V-J Day parade, Gervais Street at Main Street, August 14, 1945. The end of World War II not only challenged city fathers to address the needs of returning veterans but also raised questions about the future of Fort Jackson. Samuel Latimer Papers, 22-973. *Courtesy of South Carolinian Library, University of South Carolina, Columbia, South Carolina.*

needed entertainment—a need that the United Service Organization (USO) and similar groups tried to address. For example, in July 1941, with 400,000 men expected for fall maneuvers, leaders in Columbia planned for the influx. They requested $190,000 to construct an additional center for white soldiers and $32,000 to build a new center for black soldiers. In addition, there were again concerns about prostitution.[79]

World War II ended in 1945, and by 1949, the future of the fort was again in jeopardy. The outbreak of hostilities in Korea halted talk of closure. Fort Jackson trained troops for the Korean War. With the desegregation of the United States military, Fort Jackson became, according to Andrew Myers, "one of the first army installations to undergo large-scale desegregation." During the 1960s, the fort trained troops for service in Vietnam and, in 1967, was the site for the court-martial of Captain Howard Levy. During the 1970s, the fort held "gender-integrated" training for male and female recruits.

Despite periodic threats of closure, by the end of the twentieth century, "Fort Jackson was the army's largest training post for new soldiers."[80] Fort Jackson was a critical player in Columbia's economic well-being. Consequently, civic leaders actively campaign to protect the facility from base closings and military cutbacks.

Owens Field

The opening of Owens Field provided air access to Columbia. The dream of Columbia mayor Dr. L.B. Owens, Owens Field (or Columbia Owens Downtown Airport) is located in Rosewood. Dedicated on April 25, 1930, Owens Field was the first commercial airport in the Midlands. Completed in 1929, the Curtis-Wright Hangar was the first structure built at Owens Field. In 1932, Eastern Airlines offered passenger service, and in 1934, Delta Airlines offered another option for passengers. During the 1930s, dignitaries such as President Franklin D. Roosevelt and Amelia Earhart used the airfield. After World War II, operations moved from Owens Field to Columbia Metropolitan Airport in Lexington County (developed during the war as an army air facility on the site of the former Lexington County Airport).[81]

BRAVE NEW WORLD

There are two ways to meet a difficulty. One is to alter the difficulty and the other is to alter yourself to meet the difficulty.

—Lester L. Bates Sr.

In 1950, the city of Columbia was enjoying the postwar boom. Thousands of veterans returned seeking homes, employment and, as a result of the GI Bill, a college education. The University of South Carolina scrambled to accommodate the influx of mature students. The demand for housing also boomed.

The city adopted the city-manager form of government. Despite this decision, powerful mayors continued to direct and influence the city's development. Among the more noteworthy of these late twentieth-century mayors were Lester Bates, Patton Adams, Kirkman Finlay and the latter's protégé, Bob Coble.

In addition, the situation for Columbia's African Americans changed in the 1940s. In 1944, the United States Supreme Court ruled that African Americans were eligible to vote in state primaries. In 1947, Judge J. Waties Waring ended the all-white Democratic primary in South Carolina. In a state with only one political party, the primary was the only opportunity for voters to directly select candidates for office. In *Elmore v. Rice*, Waring ruled, "South Carolina is the only State which conducts a primary election solely for whites…. I cannot see where the skies will fall if South Carolina is put in the same class with…other states." As a result of the Supreme

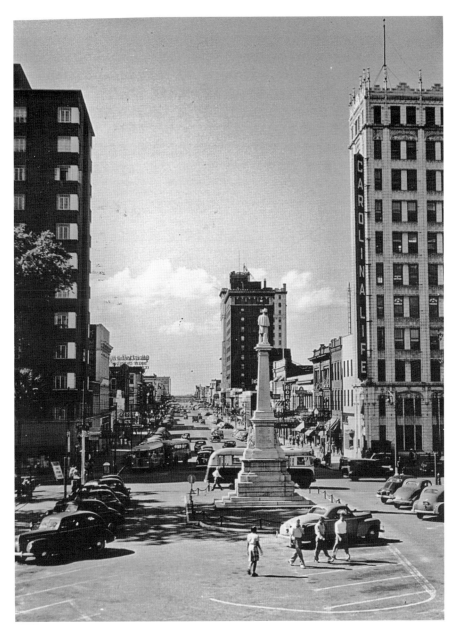

Main Street looking north from the statehouse, circa 1955. South Carolina Department of Transportation, S233002. *Courtesy of South Carolina Department of Archives and History.*

Next page: Black voters, 1948 primary election. Mrs. Juliette Gilliam is in the middle, reading a booklet, and William Gilliam is second behind her. John H. McCray Papers. *Courtesy of South Caroliniana Library, University of South Carolina.*

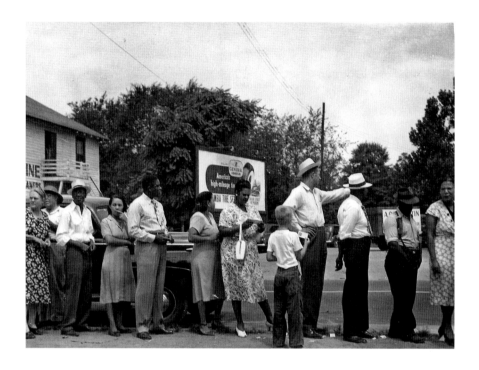

Court's decision and Waring's ruling, John McCray and other black leaders organized the Progressive Democratic Party, which was renamed Progressive Democrats in 1948. The outcome of these developments was the end of the white primary in South Carolina. In 1948, black residents lined up to vote in the democratic primary.[82]

LESTER LEE BATES SR.

On the face of it, Lester Lee Bates Sr. was an unlikely mayor. Born around 1904 to a tenant farming family in Hell Hole Swamp, Berkeley County, Bates had few early opportunities. Yet like Horatio Alger, he persevered and, in 1936, founded his own insurance company, Capital Life and Health Insurance Company, in Columbia. In 1944, Bates won his first term on city council and was reelected to a second term. He also ran unsuccessfully for governor in 1950 and 1954. In 1958, by the slim margin of fourteen votes, Columbia residents elected Lester Bates mayor. He served three terms as mayor of Columbia.

During his tenure as mayor, for the second time, Columbia was named an "All-American City." In 1962, Columbia Metropolitan Airport opened, and the city annexed Fort Jackson. In the difficult days of desegregation, perhaps Bates's most important contribution was the creation of the Columbia Community Relations Council. Organized in 1964, the ten-member council was a biracial group to advise the city on desegregation issues. Reverend Roscoe Wilson Sr. was one of the original members of the Community Relations Council. The council lasted into the 1990s. Mayor Bates died in 1988.[83]

Mayor Lester Bates (1904–1988) served three terms as mayor of Columbia between 1958 and 1970. During his tenure, black and white residents worked together to desegregate lunch counters and integrate the University of South Carolina. Lester Bates Papers. *Courtesy of Modern Political Collection, Cooper Library, University of South Carolina.*

With Columbia long a Democratic stronghold, the 1950s brought signs of Republican resurgence. Popular President Dwight David Eisenhower visited Columbia, with parades, bands and much hoopla. His then vice president Richard Nixon also visited Columbia during his first, unsuccessful run for the White House. *Brown v. Board of Education* and Congressional efforts to pass voting and other civil rights legislation concerned Columbia and South Carolina's leaders.

For example, in 1948, the same year black voters won the right to vote in the state's Democratic primary, former South Carolina governor J. Strom Thurmond and more than thirty other southern Democrats walked out of the national convention. The dissenting Democrats convened their own convention and selected Thurmond as their presidential candidate. Thurmond, running on the States' Rights Democratic Party (or, more familiarly, "Dixiecrat") ticket, carried four Deep South states (Alabama, Louisiana, Mississippi and South Carolina) and captured thirty-nine electoral votes.

Columbia's black residents continued their efforts to create the services they needed. These services included hospitals and clinics. In 1952, two

black hospitals merged to form Good Samaritan–Waverly Hospital. In the face of discrimination, Good Samaritan–Waverly Hospital, located at the corner of Hampton and Pine Streets, offered modern medical care for Columbia's black residents from 1952 to 1973. The facility also offered the only exclusive training program for black nurses. Unfortunately for Good Samaritan–Waverly, the integration of white hospitals and the construction of Richland Memorial in 1972 signaled the end of this black institution. Good Samaritan–Waverly officially closed in 1973.

CIVIL RIGHTS IN COLUMBIA

One of Columbia's leading civil rights leaders was Modjeska Monteith Simkins. Her career officially began when she graduated from Benedict College in 1921. Initially, she taught at Booker T. Washington High School, but in 1931, she became Director of Negro Work for the South Carolina Anti-Tuberculosis Association. Additionally, she continued her involvement with the NAACP. From 1941 to 1957, she served as secretary of the Columbia chapter of the NAACP. She successfully lobbied for equal pay for black teachers in Sumter and Columbia. She spoke and wrote, pushing forward black voting rights and social change. Simkins was also involved in drafting documents for *Briggs v. Elliott*, the Clarendon County, South Carolina case that became part of *Brown v. Board of Education of Topeka, Kansas*. On March 25, 1994, the home of this social reformer was listed on the National Register of Historic Places.[84]

On May 17, 1954, *Brown v. Board of Education* dealt a deathblow to segregation in the United States. While southern states organized to resist, black educators meeting in Hot Springs, Arkansas, welcomed the decision and "look[ed] upon it as another significant milestone in the nation's quest for a democratic way of life." Among those in attendance was J.A. Bacoats, president of Benedict College.[85]

The 1950s and 1960s were times of unrest and demonstrations. An early incident involved city buses operated by SCE&G Company. On June 22, 1954, a young black woman took the only open seat on a crowded bus. Unfortunately for her, the seat was near the front of the bus in the white-only section. The bus driver ordered the passenger to move to the back, and when she wanted to leave the bus instead, the driver physically forced her to use the rear "black" door. She sued SCE&G.

According to Randall Kennedy, during the 1960s, protests in Columbia "were particularly numerous and strong." For example, police arrested two black students for refusing to leave a booth at a local Eckerd's drugstore. Eckerd's refused to serve food to black patrons and summoned the police. While demonstrations in Columbia were generally nonviolent, in 1961 a young Benedict student was stabbed during a lunch counter protest. On August 21, 1962, James Hinton was the young black man who sat down at the Eckerd's all-white lunch counter. Also, the Taylor Street Pharmacy was the scene of another demonstration. Although Taylor Street would serve black patrons at the food counter, they were not allowed to sit and eat their food. So, when five students violated the store's policy, police also arrested them.

Civil rights activist and educator Modjeska Simkins (1899–1992) was instrumental in challenging the white-only Democratic primary, the doctrine of "separate but equal" public education and unequal pay for black and white teachers. Modjeska Simkins Papers. *Courtesy of Modern Political Collection, Cooper Library, University of South Carolina.*

And on March 2, 1961, about two hundred students walked from Zion Baptist Church to the statehouse protesting segregation. Protestors carried signs voicing their displeasure with the status quo. Although the students reached the statehouse without incident, police ordered them to disperse. When the students continued to sing and clap, the police arrested them.

Although these are only a few incidents from those difficult years, these cases are important. All of them reached the United States Supreme Court, and through the efforts of Matthew J. Perry and other attorneys, the students' convictions were overturned. Perry, a native of Columbia and prominent civil rights attorney, later served as a judge for the United States Court of Military Appeals and the United States District Court of Appeals in South Carolina.[86]

Student protests continued for two years in Columbia. Beginning in August 1962, Reverend Roscoe Wilson began leading lunch protests. He took a few

protestors to a few stores each day. According to Wilson, who was pastor of St. John Baptist Church in 1994, he wanted white citizens to "see that the sun would still shine and that no blood would be shed" if black customers were served at white lunch counters.[87]

INTEGRATION/DESEGREGATION

Ethel Bolden, a member of the interracial council created by Mayor Bates, commented in 1994, "Columbia was quietly integrated and it wasn't by accident; people were working together for peaceful integration." On January 16, 1963, Governor Donald S. Russell and his wife hosted, according to Walter Edgar, the "first racially integrated state function in nearly a century." The barbecue on the grounds of the Governor's Mansion was open for "all South Carolinians."[88]

Governor Richard Riley applauds space shuttle astronaut and Columbia native Colonel Charles Bolden during a joint assembly of the General Assembly on April 23, 1986. On July 17, 2009, President Barack Obama appointed Major General Charles F. Bolden Jr. (USMC-ret) administrator of the National Aeronautics and Space Administration. Governor Richard Riley Papers, S5554023. *Courtesy of South Carolina Department of Archives and History.*

South Caroliniana Library, University of South Carolina, April 1934. Although the building originally housed the university's first library, after the construction of McKissick Library in 1940, the former library housed South Carolina books and manuscripts. Historic American Buildings Survey, M.B. Paine, photographer. HABS SC, 40—COLUMB, 2A-1. *Courtesy of Library of Congress, Prints & Photographs Division.*

Also, on September 11, 1963, three black students enrolled at the University of South Carolina. The students were Henrie D. Monteith of Columbia, Robert G. Anderson of Greenville and James L. Solomon of Sumter. USC president Thomas F. Jones Jr. and Dean Charles H. Witten carefully organized for "I-Day" (Integration Day)—the first admission of African American students since Reconstruction.

Yet the decision to integrate was an abrupt departure for USC. In the 1950s, the university had fired faculty for favoring integration and reprimanded several students for participating in civil rights demonstrations. In 1962, USC had rejected Monteith's initial application for admission. As a consequence, Monteith enrolled at Notre Dame College in Maryland. At the end of her freshman year, she reapplied to USC. In July 1963, United States district judge J. Robert Martin handed down a decision requiring the university to admit Monteith. Six

months earlier, Harvey Gantt had enrolled, without incident, at Clemson University.[89]

Nevertheless, integration had a downside. Among the casualties were black-owned businesses that served the city's black neighborhoods. Such business districts flourished along Washington Street and near Allen University and Benedict College on Harden and Taylor Streets. During much of the twentieth century, black customers either would not or could not shop in white-owned stores on Main Street. Well-known black enterprises included the Victory Savings Bank, North Carolina Mutual Insurance Company, the Royal movie theater, Counts Drug Store and Jenkins Grocery store. These businesses did more than just meet basic and social needs. For example, Victory Savings Bank offered black entrepreneurs business loans. Yet integration and urbanization forever changed Columbia's black neighborhoods. In addition, the University

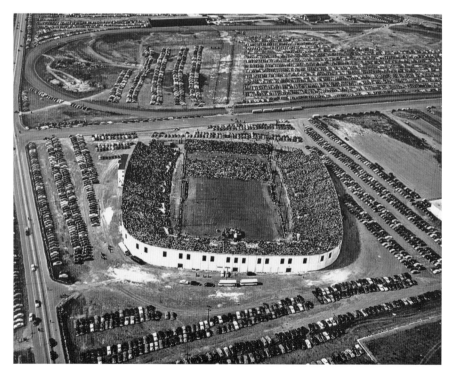

Aerial view, Billy Graham crusade, University of South Carolina football stadium. Noted evangelist Billy Graham held his first Columbia crusade in 1950. This photograph possibly documents that crusade. South Carolina Department of Transportation, S2330002. *Courtesy of South Carolina Department of Archives and History.*

A new look for the former Confederate printing plant, Gervais Street, 2014. During the Civil War, Evans & Cogswell moved its printing operation from Charleston to Columbia. Although it burned in February 1865, the exterior walls survived and the structure was rebuilt. *Photograph by Terry L. Helsley.*

of South Carolina expanded into historically black neighborhoods such as Wheeler Hill and surrounded black schools such as Booker T. Washington, and the resulting gentrification of areas such as the Vista increased property values but forced relocations.[90]

IDENTITY CRISIS

Columbia has faced adversity. Sometimes our economic opportunities have not been as great as others. Yet against a sometimes steeper climb, we have made progress. We have acknowledged our recent history, the spirit of openness and fair play, the sense of community that can be part of the experience of each citizen.
—Kirkman Finlay Jr.

Desegregation triggered "white flight" to burgeoning suburban communities. The city of Columbia struggled with recurring image issues—concerns about the public schools, crime, losses of downtown shopping opportunities, crumbling infrastructure, public transportation, quality of law enforcement, economic opportunities and decaying properties and public housing. These concerns slowed municipal development. In 1990, according to the census, the city reported a population of 42,837.

Significant mayors of the twentieth century included Lester Lee Bates (1904–1988), Kirkman Finlay (1908–1971), Patton Adams and Bob Coble. These strong mayors changed the city of Columbia. They increased the city's boundaries; organized efforts to revitalize the Vista (Gervais Street corridor); reclaimed the site of Seaboard Park, the original Sidney Park; and launched controversial attempts to upgrade Main Street—the hotly debated and soon removed light poles planted in the middle of the street.

In 1970, during the administration of Mayor Finlay, the state of South Carolina commemorated its 300th anniversary. The Tricentennial Commission sponsored a series of publications exploring the state's history

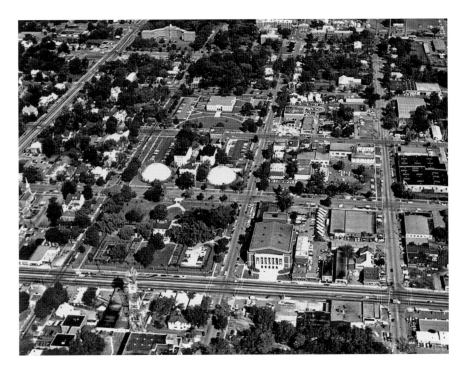

Aerial view, Tricentennial Exhibition Domes, Hampton Preston House, Township Auditorium, Gervais Street, left forefront, 1970. The tricentennial celebrated the state's 300ᵗʰ birthday. The Tricentennial Commission planned three special exhibition venues in Charleston (Old Town Landing), Greenville (Roper Mountain) and Columbia (Hampton Preston and Robert Mills Houses). The Charleston exhibit celebrated the state's first century, the Midland's venue the state's second century and the daring Buckminster Fuller–designed cube on Roper Mountain the state's third century. South Carolina Department of Transportation, S233002. *Courtesy of South Carolina Department of Archives and History.*

and planned three exhibition centers—one in Charleston, one in Columbia and one near Greenville. The Charleston center at Old Town Landing focused on the first hundred years of the state's history. The Columbia center on the grounds of the Hampton Preston House presented the state's second hundred years, and the third center on Roper Mountain near Greenville exhibited the last century of South Carolina's development. From the beginning, there were challenges, questions about spending, lawsuits and the infamous problems with the Roper Mountain site. Still, for Columbia, the domes brought renewed interest in the city's historic homes and a challenge to restore and preserve that history.

In 1974, Columbia residents enjoyed the fulfillment of a long-held dream: the opening of Riverbanks Zoo and Garden. O. Stanley Smith and Don

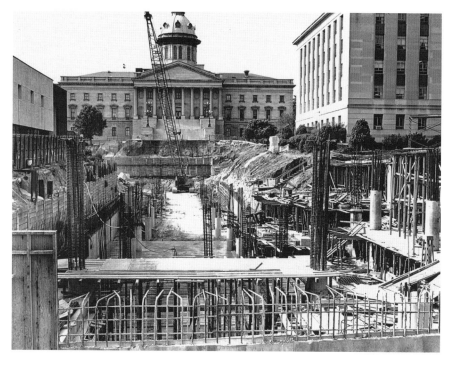

Underground garage construction, capitol complex, south face of the statehouse. In 1969, construction began on the new capitol complex. Part of the project was an underground parking facility for legislative and staff use. By 1971, part of the underground garage had been opened. South Carolina Department of Transportation, S2330002. *Courtesy of South Carolina Department of Archives and History.*

Barton were instrumental in bringing this dream to fruition. The dream began in 1964 with a tiger named "Happy" and Columbia schoolchildren donating pennies and nickels to help fund the zoo. Eventually, the zoo opened, and Happy had a permanent home.

In April 2000, grateful residents gathered at Finlay Park to honor former mayor Kirkman Finlay and his contributions to improving Columbia. Although Finlay died in 1992, his accomplishments continue. The tribute included the unveiling of a life-size statue depicting Finlay "kicking back on a park bench." Alex Sanders, then president of the College of Charleston and a childhood friend of Finlay, commented, "To say that he was a great mayor is a vast understatement…To say that he was a great visionary is almost a cliché. His dream for Columbia…has only begun to unfold."

Kirkman Finlay served as mayor between 1978 and 1986. His accomplishments included relocating railroad tracks; opening city

Finlay (formerly Sidney) Park, 2014. The name honors former mayor Kirkman Finlay and his efforts to create the new park and revitalize downtown. *Photograph by Terry L. Helsley.*

Governor Richard Riley signs documents designating the Mount Vernon Mills, the former Columbia Mills, as the South Carolina State Museum, December 7, 1981. An example of adaptive reuse, the South Carolina State Museum officially opened the renovated mill in the fall of 1988. Governor Richard Riley Papers, S5554023. *Courtesy of South Carolina Department of Archives and History.*

government to black and women voters; amenities such as the Koger Center and the South Carolina State Museum; and seeing the potential in a derelict warehouse district surrounding Gervais Street—the old commercial connection between the city and the river. Finlay called the area "the Congaree Vista."[91]

COLUMBIA'S BICENTENNIAL: "LOOKING BACK; REACHING FORWARD"

In 1986, the city of Columbia spectacularly celebrated its 200th birthday. A massive fireworks display on New Year's Eve 1985 ushered in the city's birthday year. The well-known Grucci family, who produced the fireworks

Columbia's bicentennial logo. In 1986, the city of Columbia had an exciting birthday, celebrating two hundred years with fireworks, concerts, balls and neighborhood festivals. *Collection of the author.*

Governor Richard Riley (right) and James Holderman, president of the University of South Carolina, at a photo shoot at the Governor's Mansion, July 29, 1985. Holderman was one of USC's more flamboyant and controversial presidents. Governor Richard Riley Papers, S5554023. *Courtesy of South Carolina Department of Archives and History.*

display for the opening of the 1984 Olympics, orchestrated the "most spectacular fireworks display in the city's history." Neighborhoods such as Arsenal Hill, Earlewood, Harbison and Hopkins sponsored bicentennial festivals featuring games, tours and musical performances, as well as food and craft vendors. The Harbison Festival ("Living and Learning"), for example, included the premiere of "One Day in the Life of Columbia," which showcased photographs taken in the city during one twenty-four-hour period. Local photographers, such as Jeff Amberg, participated. Event planners also published a history of the community. Other neighborhoods sponsored tours and storytelling.

O. Stanley Smith Jr. chaired the Bicentennial Steering Committee. Other members of the committee were Thomas N. McLean, Edwin Russell, Mrs. I.S. Leevy Johnson, A.T. (Gus) Graydon, Hyman Rubin Sr., Mrs. Edmund R. Taylor, William C. Ouzts, T. Patton Adams, Major General Robert B. Solomon and David G. Ellison Sr. As part of the festivities, the committee opened the 1936 time capsule and buried another one. The celebration also included gala balls; gold, silver and bronze commemorative coins; T-shirts; posters; a special flag; an anthem; and the debut of a documentary, *Columbia: Memories of a City*. In addition, Charles Dutoit conducted the Philadelphia Orchestra in a special concert at the Township Auditorium. The festivals and city celebrations highlighted the rich cultural diversity of the capital city.

At two hundred years, Columbia was alive and well and looking forward to another century. In 1968, the Columbia Coliseum opened, and the USC Gamecocks won a thrilling game against Auburn thanks to a last-minute goal by guard John Roche. In 1969, the Coliseum welcomed the Ringling Bros. and Barnum & Bailey Circus. The initial elephant walk from the railroad cars to the coliseum became an anticipated annual event.

Opposite, top: With the statehouse in the background, Governor Richard Riley congratulates Senior Senator Rembert C. Dennis at the dedication of the Dennis State Office Building, July 15, 1981. Dennis (1915–1992), who represented Berkeley County, served in the South Carolina Senate from 1943 to 1988. According to Senator Isadore Lourie, Dennis "was one of the giants in the South Carolina Senate, and when he left the Senate, it was truly the end of that era." Governor Richard Riley Papers, S5554023. *Courtesy of South Carolina Department of Archives and History.*

Opposite, bottom: Main Street, festively decorated for the holidays, looking south toward the statehouse, circa 1973. The 1970s were a transitional time for Main Street merchants. While major department stores—such as Tapp's, with its lunch room and "Meet Me at Tapp's" slogan—still drew shoppers downtown, suburban malls grew in popularity. South Carolina Department of Transportation, S233002. *Courtesy of South Carolina Department of Archives and History.*

The 1970s were years of promise, planning and possibilities. The Doxiadis Plan proposed ways to address the city's long-term transportation needs. The capitol complex expanded bringing new facilities and new employment options for Columbians. Eventually, the expansion included two office buildings and a parking garage.

In addition, the South Carolina–Georgia Synod of the United Presbyterian Church and its board of national missions created a nonprofit corporation to develop the new town of Harbison—a planned unit development. Not only did the proposed development have designated spaces for single-family and multi-family housing and commercial, religious and educational activities, but it was also racially and economically integrated. Harbison was a departure for the Columbia metropolitan area. One leading residential builder blasted the development as "an instant slum." Yet the Doxiadis plan, the possibilities of Harbison and the city's equal-employment plan all spoke to Columbia's potential to address the complexities of modern urban life without sacrificing its past to unplanned, unequal "growth."[92]

UNFINISHED BUSINESS

As South Carolina's capital, Columbia cannot avoid the spotlight or controversies that embroil the statehouse. For years, the issue of the Confederate flag has attracted much press and has been a thorn in Columbia's side. The story of this issue begins in 1962, when, in support of the centennial of the outbreak of Civil War, the South Carolina legislature by a joint resolution voted to place the Confederate battle flag atop the state capitol. According to Ben Hornsby, the authors of the resolution distributed folded flags to each member of the General Assembly. Little is known about the background or purpose of the resolution or the intentions of the proposers—that is, whether a centennial showing of the colors or a permanent placement. At the time, the Confederate flag was also displayed inside the capitol as well.

Regardless, the Confederate flag is a polarizing symbol. To many African Americans, the flag represents the desperate, degrading days of slavery and its enduring legacy. On the other hand, some white South Carolinians talk about heritage and honoring the fallen—war and remembrance. In the capital city, with racial barriers coming down and increased black involvement in the political process, it seemed to some a

With outstretched arms, Governor Richard Riley presents his eighth and final State of the State address, 106th General Assembly, January 22, 1986. Raymond Schwarz, Speaker of the House of Representatives, is to the left of the governor. One highlight of Riley's tenure was passage of the Education Improvement Act. Governor Richard Riley Papers, S5554023. *Courtesy of South Carolina Department of Archives and History.*

good time to resolve the issue and remove the flag. In 1983, Representative Kay Patterson, elected from Richland County, sponsored legislation to remove the flag from the statehouse. The measure failed. That same year, Reverend I. DeQuincey Newman became the first black member of the South Carolina Senate since Reconstruction.

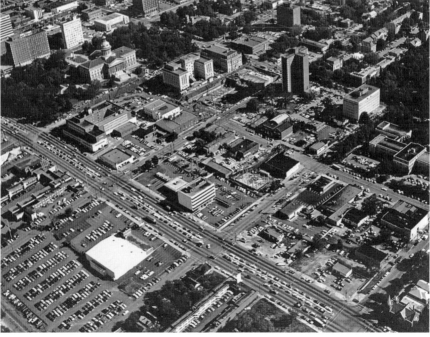

When nothing changed, the NAACP announced in 1994 an economic boycott of South Carolina. The boycott cost South Carolina a number of athletic contests, a possible bowl and unknown numbers of conventions. Still, little changed until 1996, when Governor David Beasley proposed a compromise. Unfortunately, it is possible that Beasley's efforts vis a vis the flag cost him reelection.[93]

But the 1980s were also a time of economic downturns. Banks and savings and loans closed and/or merged. As corporate headquarters moved and businesses closed, the face of Main Street changed. Mergers usually meant job losses or relocations. Uncertainty was bad for employee and community morale. Walter Edgar reported that three consecutive presidents of the Columbia Chamber of Commerce could not complete their terms in office due to relocations. With the resultant loss of income, the city looked for ways to recoup.

SHOESTRING ANNEXATION

In the second half of the twentieth century, the City of Columbia aggressively pursued annexation as a means to increase the city's tax base. The explosive growth of the University of South Carolina, state government and other nontaxable entities, such as Palmetto Baptist Hospital, coupled with white flight to the suburbs in the 1970s greatly reduced the city's taxable properties. Some of these annexations were controversial. One such annexation not only aggravated residents along the I-26 corridor but also provoked the city of Irmo in Lexington County. In 1989, the City of Columbia employed a "shoestring" annexation in order to add the upscale Columbiana Centre to the city.

The shoestring was a five-foot-wide, approximately 1.5-mile-long strip of land along Broad River Road. Columbia Centre Mall was part of

Opposite, top: Governor Richard Riley shakes hands with Mrs. Newman minutes after civil rights activist and Methodist minister Dr. I. DeQuincey Newman (1911–1985) was sworn in as the state's first black senator since Reconstruction, November 4, 1983. From 1960 to 1969, Newman served as state field director for the NAACP. Governor Richard Riley Papers, S5554023. *Courtesy of South Carolina Department of Archives and History*.

Opposite, bottom: Aerial view, capitol complex. South Carolina Department of Transportation, S2330002. *Courtesy of South Carolina Department of Archives and History*.

Public art installation, plaza, Columbia Museum of Art, Main Street, 2014. In 1998, the Columbia Museum of Art, founded in 1950, relocated from Senate Street to this new facility. The museum's move helped spur the current Main Street renaissance. *Photograph by Terry L. Helsley.*

142

the Harbison Planned Unit Development that lay within the bounds of Lexington County, and the city of Irmo had annexation efforts underway at the time of Columbia's preemptive strike. Irmo town officials and many Harbison residents opposed Columbia's actions. As state law governing annexations was unclear, there were a number of legal challenges. In 1999, State Attorney General Charlie Condon, an opponent of the annexation, stated, "Columbiana Centre is in Irmo. It isn't in Columbia." The shoestring involved land in the floodplain and the city's covetous desire for tax revenue from the new mall with eighty stores.

Earlier, in May 1990, then mayor-elect Bob Coble convened a public meeting to hear Harbison and Lexington County residents' concerns. While residents vocally shared their displeasure and Coble made conciliatory statements, nothing changed. The South Carolina Supreme Court heard a number of legal protests, most of which it dismissed on procedural issues. In the end, after more than ten years, the City of Columbia prevailed, and individuals with traffic difficulties in the area face a tangled jurisdictional web navigating between city and county law enforcement.[94]

In 1998, the Columbia Museum of Art moved from a historic house on Senate Street to a new facility on Main Street. Founded in 1950, the museum was able to expand its gallery space, enhance its collections and develop a wide range of public programming. The museum's move to Main Street began the slow but steady revitalization of Columbia's downtown.

BIG LITTLE CITY

Everyman's city.

—*Robert Pierce, 1985*

For Columbia, the twentieth century was one of growth—faltering, but steady—and of great change: Fort Jackson, integration, the Vista and much more. It was also a time of questions and challenges. Some of these remain unanswered. For example, can Columbia maintain its distinct "hometown" feel? Can the city escape the mind-numbing sameness of urban blight? Does the city have the heart to claim and preserve its past? Can it escape the fate of Atlanta and Charlotte (big, but without heart or history)? Can Columbia be a better place for all its citizens to live and work? Can planning control the amoeba-like spread of the University of South Carolina, reduce urban blight and find the answer to the city's burgeoning traffic woes? The jury is out, but in the meantime, Columbia has entered the twenty-first century with much on the plus side of its ledger.

Amenities include the award-winning Riverbanks Zoological Gardens, the South Carolina State Museum and entertainment venues such as the Koger Center, Columbia Convention Center and Township Auditorium. In addition, Columbia is home to the state's leading research university, the University of South Carolina and its law school, as well as Columbia College, Benedict University, Allen University and numerous other campuses.

A special coup was the decision of the Department of Justice in 1991 to locate the National Advocacy Center on the corner of Pendleton and Pickens

Neverburst, public art created by Blue Sky, Main Street, 2014. Blue Sky installed the twenty-five-foot-long chain that connects two historic buildings in 2000. *TunnelVision*, a mural on the old AgFirst Farm Credit Bank, also by Blue Sky, is probably Columbia's best-known public art installation. *Photograph by Terry L. Helsley.*

Streets. The Executive Office for United States Attorneys operates the NAC on the campus of the University of South Carolina. Annually, the center trains twenty thousand district attorneys and Justice Department staff. Senator Fritz Hollings was instrumental in moving the center from Washington, D.C., to Columbia. The move was controversial. In Washington, critics of the plan alleged "pork barrel" politics, and many employees did not want to relocate. At home, Columbia city leaders wanted the center downtown and not on the campus of USC, while faculty at USC complained about the loss of parking (the site had been a parking lot). Yet the Justice Department wanted the center on the USC campus, and Hollings's office touted the cost savings associated with the Columbia site—a centralized facility with lower overhead and less expense for visitors.[95]

In 2004, the Columbia Metropolitan Convention Center opened on Lincoln Street in the Vista. The 142,500-square-foot convention center, built at a cost of $37.4 million, opened in November. According to *The State*, Columbia was the "last capital in the United States to get a first-rate convention center." In the 1960s, the City of Columbia had begun exploring the possibility of a convention center and through the years explored

different sites. In the 1980s, Mayor Kirkman Finlay and his successor, Mayor Patton Adams, approached USC about a joint venture and tried to interest investors in building a major hotel near the Carolina Coliseum. Still, there was no progress, and in 1995, a somewhat frustrated Mayor Bob Coble commented that the site question was incidental but that the city *needed* a convention center. Eventually, thanks to the work of Mayors Finlay, Adams and Coble, as well USC athletics director Mike McGee and others, officials broke ground for the convention center in 2002.[96]

In 2000, according to census data, the city of Columbia had a population of 116,278. The city's policy of using access to city water and sewage services to leverage annexation has added countless communities to the city's ever-expanding city limits. The twentieth century saw a number of controversial annexations and annexation attempts as the city expanded its borders.

In 2000, the state finally addressed the polarizing issue of the Confederate flag. In 1998, Jim Hodges became governor of the state. Elected with a campaign promise to keep the flag flying, Hodges initially avoided the flag issue. Yet pressure mounted for action. In addition to the NAACP, the South Carolina Baptist Convention, the South Carolina travel industry, members of the 1962 general assembly, USC football coach Lou Holtz, Charleston mayor Joe Riley and many others spoke out in favor of moving the flag. In 2000, the South Carolina Senate and House approved a measure to remove the Confederate flag from the statehouse and instead fly a Confederate flag near the Confederate monument. Still, the compromise did not please all South Carolinians or all Columbians. As late as 2014, a Winthrop poll revealed that the flag was still a "racially divisive symbol in South Carolina."[97]

COLUMBIA: "ALL-AMERICAN CITY"

Columbia wears many hats. It is the state capital, the seat of Richland County and the home of both the University of South Carolina (and the Fighting Gamecocks) and Fort Jackson. Situated in the center of the state, Columbia is the historic hub of the Proprietary and colonial Indian trade and the modern spaghetti junctions of Interstates 26, 20 and 77. It is a river city that has reclaimed its waterfront. For residents and visitors, Columbia is a kaleidoscope of changing colors, lights and sounds—of possibilities past and present, of dreams found and lost. It is a city with a past and a future.

"Famously Hot, or Not?"

C olumbia has survived disdain, neglect, burning, unequal economic opportunities, war, civil disturbances and short-sighted development. Yet almost daily, the brick-and-mortar remains of its distinguished past disappear. Vistas are lost, and buildings are destroyed by the wrecking ball. The dome of the statehouse no longer dominates the horizon. Cherished ballparks become shopping centers; greenswards around the state mental hospital will be paved for parking and a new ballpark; and perhaps most egregious of all, an upscale residential development sits on the site of South Carolina's former death house, where hundreds of South Carolinians—men and women, black and white, old and the fourteen-year-old George Stinney Jr.—paid the ultimate price for their crimes.

And yet, on the other hand, much is positive. In the summer of 2011, Mast General Store opened in a landmark building on Main Street. For almost fifty years, the building housed Lourie's Department Store. Mast General Store is a family of retail stores based in Valle Crucis, North Carolina. Later, the Nickelodeon Theatre renovated the old Fox Theatre and relocated next door. During the day, Main Street bustles with workers and students, and in the evenings, award-winning restaurants lure diners. In April 2010, the city entered a new chapter in its long history. A record turnout elected Steve Benjamin, Columbia's first African American mayor. Benjamin, an attorney, served as director of the Department of Probation, Parole and Pardon and has an enviable record of civic service to his state and community.

Mayor Steve Benjamin, Columbia's first African American mayor, 2014. Elected in 2010, Mayor Benjamin has an impressive vision for the future of Columbia. Plans include the redevelopment of the Department of Mental Health property and the construction of a new minor-league baseball park for the city. *Courtesy of the Office of Mayor Steve Benjamin.*

Columbia Water Plant, Power House, Columbia Canal and Power Plant, 2014. Without the rivers, Columbia would not exist. *Photograph by Terry L. Helsley.*

There is something restorative about a morning stroll through Riverfront Park. While the manmade environment—the canal, the waterworks and the hydroelectric plant—occupies center stage, the backdrop is natural. Trees line the riverbanks, huge boulders hug the shoreline and there is the river, a permanent link between the Columbia of 1786 and the Columbia of today—a "Capital City."

A Columbia Timeline

1718—Commons House of Assembly establishes Fort Congaree.

1786—South Carolina General Assembly creates a new capital.

1791—President George Washington visits Columbia.

1801—South Carolina General Assembly establishes South Carolina College (University of South Carolina).

1805—City of Columbia is incorporated; South Carolina College holds first classes.

1825—Revolutionary hero the Marquis de Lafayette visits Columbia.

1827—First bridge is opened across the Congaree River.

1832—Nullification Convention meets in Columbia, ratifies the Ordinance of Nullification.

1842—First passenger train arrives in Columbia.

1851—South Carolina General Assembly authorizes construction of a new statehouse.

1854—South Carolina Methodists found Columbia College.

1859—Sidney Park is opened.

1860—South Carolina Secession Convention is convened and organized at First Baptist Church.

1865—Mayor Thomas J. Goodwyn surrenders Columbia to Union troops; "Burning of Columbia" takes place.

1867—Last public hanging in Columbia is held.

1870—American Baptists establish Benedict College, Columbia's first African American institution of higher education; the YMCA is opened.

1880—Allen University is opened.

1886—Columbia commemorates its centennial.

1891—The State Company founds *The State* newspaper.

1894—Columbia Mills, the city's first electric-power textile mill, is opened.

1896—First football game between Clemson and Carolina is played at the fairgrounds.

1897—Columbia hospital is opened.

1907—Booker T. Washington speaks at the Columbia Theatre.

1909—President William Howard Taft visits Columbia.

1917—Camp Jackson is opened as a military training base.

1919—Town Theatre presents its first productions.

1928—Congaree River (Gervais Street) Bridge is opened.

1929—First commercial air passengers arrive at Owens Field.

1930—Largest earthen dam in the world, at the time, creates Lake Murray to furnish hydroelectric power for SCE&G.

1930—Opening broadcast of Columbia's first broadcasting station takes place.

1932—Columbia Veterans Affairs (VA) Hospital is opened.

1934—Columbia Stadium is completed.

1935—World War Memorial is completed.

Pipe detail, Columbia Water Plant, Riverfront Park, 2014. Riverfront Park is a scenic pathway along the rivers, canal and waterworks. *Photograph by Terry L. Helsley.*

1936—Columbia celebrates its sesquicentennial.

1940—Camp Jackson is named Fort Jackson, permanent army post.

1950—Columbia Museum of Art is opened.

1951—Columbia is named "All-American City."

1953—Columbia's first television station goes on the air.

1965—Columbia again is named "All-American City."

1965—New terminal, Columbia Metropolitan Airport, is opened.

1968—Columbia Coliseum is completed; first USC basketball game takes place: Gamecocks defeat Auburn, 52–49; city of Columbia annexes Fort Jackson.

1970—Population of Columbia passes 100,000.

1974—Riverbanks Zoo and Garden is opened.

1977—*Columbia's Commercial Heritage*, the first inventory and survey of Columbia's historic commercial buildings, is completed.

1986—Columbia celebrates its bicentennial.

1988—South Carolina State Museum is opened in the former Columbia Mills.

1990—Charles P. Austin takes office as Columbia's first black chief of police.

1991—New Sidney (later Finlay) Park is opened.

2004—Columbia Metropolitan Convention Center is opened.

2010—Columbia elects its first African American mayor, Steve Benjamin.

2011—Mast General Store is opened on Main Street.

2013—*Kiplinger Magazine* names Columbia one of the "10 Greatest Cities to Live in."

NOTES

CHAPTER 1

1. Edgar, *South Carolina*, 212–15.

CHAPTER 2

2. Merrell, *Indians' New World*, 3, 19, 55, 95, 105.
3. Helsley, *Unsung Heroines of the Carolina Frontier*, 10–11.
4. Green, *History of Richland County*, vol. 1, *1732–1805*, 16–17.
5. Joey Holleman, "What Lies Beneath," *The State*, December 3, 2014.
6. Helsley, *Unsung Heroines of the Carolina Frontier*, 10–11.
7. Ivers, *Colonial Forts of South Carolina, 1670–1775*, 44–45.
8. Helsley, *Unsung Heroines of the Carolina Frontier*, 63–68.
9. Green, *History of Richland County*, vol. 1, *1732–1805*, 114.
10. Lipscomb, *Battles, Skirmishes, and Actions of the American Revolution*, 30.
11. Montgomery, *Columbia, South Carolina*, 2.

CHAPTER 3

12. *The State*, May 19, 2002.
13. Green, *History of Richland County*, 120.
14. Ibid., 117.
15. Andrews, *History of South Carolina's State House*, 1.
16. Drayton, *View of South Carolina*, 211–12.
17. Lipscomb, *South Carolina in 1791*, 65.
18. Ibid.

19. Ibid., 57–69; Green, *History of Richland County*, 167–270.

20. Lumpkin, *Vignettes of Early Columbia and Surroundings*, 30.

CHAPTER 4

21. Lloyd Johnson, "Columbia Canal," *South Carolina Encyclopedia*, 208.

22. Montgomery, *Columbia, South Carolina*, 24–26.

23. Ibid., 43.

24. Graydon, *Tales of Columbia*, 45.

25. Elizabeth Finley Moore, "Famous Visitors to Columbia," *Columbia*, edited by Helen Kohn Hennig, 266–67.

26. Montgomery, *Columbia, South Carolina*, 41.

27. Andrews, *History of South Carolina's State House*, 29–34, 51.

28. Kathleen L. Sloan, "Operation Freedom of the Press," *South Carolina History Illustrated* 1 (August 1970): 6–7, 66–67.

CHAPTER 5

29. David O. Stowell, "The Free Black Population of Columbia, South Carolina in 1864: A Snapshot of Occupation and Personal Wealth," *South Carolina Historical Magazine* 104 (January 2003): 8–9.

30. Lesser, *Relic of the Lost Cause*, 3–4.

31. Sarah H. Rembert, "Barhamville: A Columbia Antebellum Girls' School," *South Carolina History Illustrated* 1 (February 1970): 44–48.

32. Lumpkin, *Vignettes of Early Columbia and Surroundings*, 58.

33. *New York Times*, October 26, 1864.

34. *Columbia Reader*, "Letter of Sarah Ciples Goodwyn, 22 January 1865," 57–58.

35. Alexia Jones Helsley, "William R. Huntt and the Rescue of South Carolina's Records," *South Carolina Historical Magazine* 87 (1986): 259–63.

36. *Columbia Reader*, "Letter of William Hood, 21 June 1907," 73.

37. Carroll, *Report of the Committee*, 15–16.

38. *Columbia Reader*, "Letter of Thomas Jefferson Goodwyn, 17 February 1865" and "Excerpt from George Whitfield Pepper, Personal Recollections of Sherman's Campaigns in Georgia and the Carolinas," 60.

39. Michael C. Garber Jr., "Reminiscences of the Burning of Columbia, South Carolina," *Indiana Magazine of History* 11 (December 1915): 293–94.

40. Williams, *Old and New Columbia*, 122.

41. Lumpkin, *Vignettes of Early Columbia and Surroundings*, 42–43.

42. Leiding, *Historic Houses of South Carolina*, 264–65.

43. Marion B. Lucas, "Burning of Columbia," *South Carolina Encyclopedia*, 207.

44. Stephens, *Joseph LeConte*, 92–93, 98.

45. Carroll, *Report of the Committee*, 3.

46. Simons, *Guide to Columbia*.

CHAPTER 6

47. C.A. Johnson, "Negroes," *Columbia*, edited by Helen Kohn Hennig, 306–8.

48. State Historic Preservation Office, *African American Historic Places*.

49. Letter of William Hood, June 21, 1907, *Columbia Reader* 73; Thomas, *Old and New Columbia*, 122.

50. Stephens, *Joseph LeConte*, 97.

51. Moore, "Famous Visitors to Columbia," *Columbia*, edited by Helen Kohn Hennig, 271.

52. C.A. Johnson, "Negroes," *Columbia*, edited by Helen Kohn Hennig, 306.

53. Bailey, Morgan and Taylor, *Biographical Directory of the South Carolina Senate*, 1,191–1,193.

54. Willard B. Gatewood Jr., "'The Remarkable Misses Rollin': Black Women in Reconstruction South Carolina," *South Carolina Historical Magazine* 92 (1991): 172–88.

CHAPTER 7

55. Excerpt from Robert Somers, *The Southern States Since the War*, in *Columbia Reader*, 77.

CHAPTER 8

56. Seigler, *Guide to Confederate Monuments*, 218–20, 222–24.

57. Heyward, *More Things I Remember*, 8–9.

58. Lumpkin, *Vignettes of Early Columbia and Surroundings*, 77–78; United States Geological Survey (USGS), "Historic Earthquakes: Charleston, South Carolina, 1886 September 01," http://earthquake.usgs.gov/earthqakes/states/events/1886_09_01.

59. Julie A. Rotholz, "Winthrop University," *South Carolina Encyclopedia*, 1,035–1,036.

60. John Hammond Moore, "Columbia," *South Carolina Encyclopedia*, 206.

61. Edgar, *South Carolina*, 464–65.

62. Moore, *Columbia and Richland County*, 318.

63. Ibid., 279.

CHAPTER 9

64. Helsley, *Wicked Columbia*, 69–78.

65. *The State*, November 6, 1909.

66. *South Carolina: A Guide to the Palmetto State*, 222.

67. *Christian Science Monitor*, November 7, 1918.

68. Ibid., April 9, 1918.

69. United States Department of Health and Human Services, entry for South Carolina, "The Great Pandemic: The United States in 1918–1919," http://www.flu.gov.pandemic/history/1918.

70. *Columbia Reader*, "Reminiscence of James C. Dozier, 'Camp Jackson before the Second World War,'" 139.

71. Heyward, *More Things I Remember*, 32–33.

72. *Atlanta Constitution*, April 25, 1923.

73. *Columbia Reader*, "Reminiscence of James C. Dozier," 139–40.
74. Ibid., *"The Palmetto Leader*, 28 March 1936," 122–23.
75. Hayes, *South Carolina and the New Deal*, 9, 12, 15, 37, 39, 46–47, 63, 73–74, 88–89, 92–93, 143–44.
76. *South Carolina: A Guide to the Palmetto State*, 212–14.
77. Kathleen Lewis, "Churchill's Visit to Fort Jackson," excerpt from Winston S. Churchill, *The Second World War*, in *Columbia Reader*, 140–42.
78. Banjo Smith, "Soldiers to the Left, Soldiers to the Right: That Is Columbia Today," in *Columbia Reader*, 144–45.
79. *Christian Science Monitor*, August 28, 1940; *The State*, July 14, 1941.
80. Andrew H. Myers, "Fort Jackson," *South Carolina Encyclopedia*, 334.
81. Alexia Jones Helsley, "Owens Field," *South Carolina Encyclopedia*, 694.

Chapter 10

82. Hartsook and Helsley, *Changing Face of South Carolina Politics*; Bass and Poole, *Palmetto State*, 91.
83. Lester Lee Bates Sr. Papers, South Carolina Political Collections, University of South Carolina, http://library.sc.edu/file/212.
84. Jill K. Hanson, "The Modjeska Simkins Home," *OAH Magazine of History* 12 (1997): 18–19.
85. George Breathett, "Black Educators and the United States Supreme Court Decision on May 17, 1954," *Journal of Negro History* 68 (Spring 1948): 201, 205.
86. Kennedy, "Matthew J. Perry," 1, 6–7, 10–11.
87. *The State*, February 1, 2004.
88. Edgar, *South Carolina in the Modern Age*, 151.
89. Carolyn Click, "Civil Rights in Columbia: Why Our Story Matters. USC in '63: Black Students Step Onto Campus," *The State*, August 17, 2013.
90. Marc Rapport, "History: Once-Thriving Districts Now Lost," *The State*, May 10, 2004.

Chapter 11

91. *The State*, April 26, 2001.
92. *Columbia Reader*, "John Egerton, 'Columbia…Where There Still May Be Time,'" 152.
93. *The State*, June 25, 2000.
94. Ibid., February 1, 1990; November 1, 1999.

Chapter 12

95. *The State*, March 18, 1993; March 25, 1993.
96. Tanya Fogg Young, "Special Report: Business Hope to Reap Center's Benefits," *The State*, November 13, 2004.
97. *The State*, June 25, 2000; November 23, 2014.

BIBLIOGRAPHY

Andrews, Judith M., ed. *A History of South Carolina's State House*. Columbia: South Carolina Department of Archives and History, 1994.

Bailey, N. Louise, Mary L. Morgan and Carolyn R. Taylor. *Biographical Directory of the South Carolina Senate, 1776–1985*. Vol. 2. Columbia: University of South Carolina Press, 1986.

Bass, Jack, and W. Scott Poole. *The Palmetto State: The Making of Modern South Carolina*. Columbia: University of South Carolina Press, 2009.

Carroll, James Parsons. *Report of the Committee Appointed to Collect Testimony in Relation to the Destruction of Columbia, S.C. on the 17th of February, 1865*. Columbia, SC: R.L. Bryan Printing Company, 1893.

Drayton, John. *A View of South Carolina*. Charleston, SC: W.P. Young, 1802. Reprint, Reprint Company, 1972.

Edgar, Walter. *South Carolina: A History*. Columbia: University of South Carolina Press, 1998.

———. *South Carolina in the Modern Age*. Columbia: University of South Carolina Press, 1992.

Graydon, Nell S. *Tales of Columbia*. Columbia, SC: R.L. Bryan Company, 1964.

Green, Edwin L. *A History of Richland County*. Vol. 1, *1732–1805*. Baltimore, MD: Regional Publishing Company, 1974. Reprint of the 1932 edition.

Hartsook, Herbert J., and Alexia Jones Helsley, comps. *The Changing Face of South Carolina Politics*. Columbia: South Carolina Department of Archives and History, 1993.

Hayes, Jack Irby, Jr. *South Carolina and the New Deal*. Columbia: University of South Carolina Press, 2001.

Hennig, Helen Kohn. *Columbia: Capital City of South Carolina, 1783–1936, with Supplement by Charles Lee, 1936–66*. Columbia, SC: State Record Company, 1966.

Helsley, Alexia Jones. *Lost Columbia: Bygone Images of South Carolina's Capital City.* Charleston, SC: The History Press, 2009.

———. *Unsung Heroines of the Carolina Frontier.* Columbia: South Carolina Department of Archives and History, 1997.

———. *Wicked Columbia: Vice and Villainy in the Capital.* Charleston, SC: The History Press, 2013.

Heyward, Zan. *More Things I Remember.* Columbia, SC: State Printing Company, 1966.

Institute for Southern Studies and the South Caroliniana Library, eds. *A Columbia Reader, 1786–1986.* Columbia, SC: R.L. Bryan, 1986.

Ivers, Larry E. *Colonial Forts of South Carolina, 1670–1775.* Columbia: published for the South Carolina Tricentennial Commission by University of South Carolina Press, 1970.

Kennedy, Randall L. "Matthew J. Perry: A Lawyer with a Cause." *Matthew J. Perry: The Man, His Times, and His Legacy.* Edited by W. Lewis Burke and Belinda F. Gergel. Columbia: University of South Carolina Press, 2004.

Leiding, Harriette Kershaw. *Historic Houses of South Carolina.* London: J.B. Lippincott Company, 1921.

Lesser, Charles H. *Relic of the Lost Cause: The Story of South Carolina's Ordinance of Secession.* Columbia: South Carolina Department of Archives and History, 1990.

Lipscomb, Terry W. *Battles, Skirmishes, and Actions of the American Revolution in South Carolina.* Columbia: South Carolina Department of Archives and History, 1991.

———. *South Carolina in 1791: George Washington's Southern Tour.* Columbia: South Carolina Department of Archives and History, 1993.

Lucas, Marion B. *Sherman and the Burning of Columbia.* Columbia, SC: University of Carolina Press, 2008.

Lumpkin, Alva M. *Vignettes of Early Columbia and Surroundings.* Columbia, SC: R.L. Bryan Company, 2000.

Maxcy, Russell. *Historic Columbia: Yesterday and Today in Photographs.* Columbia, SC: R.L. Bryan Company, 1980.

Merrell, James H. *The Indians' New World: Catawbas and Their Neighbors from European Contact through the Era of Removal.* New York: W.W. Norton & Col., 1991. Reprint of the 1989 edition.

Montgomery, John A. *Columbia, South Carolina: History of a City.* Woodland Hills, CA: Windsor Publications Inc., 1979.

Moore, John Hammond. *Columbia and Richland County: A South Carolina Community, 1740–1990.* Columbia: University of South Carolina Press, 1993.

Scott, Edwin J. *Random Recollections of a Long Life, 1806 to 1876.* Columbia, SC: C.A. Calvo Jr., Printer, 1884.

Seigler, Robert S. *A Guide to Confederate Monuments in South Carolina: "Passing the Silent Cup."* Columbia: South Carolina Department of Archives and History, 1997.

Selby, Julian A. *Memorabilia and Anecdotal Reminiscences of Columbia, SC.* Columbia, SC: R.L. Bryan, 1905.

Simons, Jane Kealhofer. *A Guide to Columbia: South Carolina's Capital City.* Columbia, SC: R.L. Bryan, 1945.

South Carolina: A Guide to the Palmetto State. American Guide Series. 5th printing. New York: Oxford University Press, 1941.

South Carolina Encyclopedia. Edited by Walter Edgar. Columbia: University of South Carolina Press, 2006.

State Historic Preservation Office. *African American Historic Places in South Carolina*. Columbia: South Carolina Department of Archives and History, n.d.

Stephens, Lester D. *Joseph LeConte: Gentle Prophet of Evolution*. Baton Rouge: Louisiana University Press, 1982.

Williams, J.F. *Old and New Columbia*. Columbia, SC: Epworth Orphanage Press, 1929.

INDEX

ABOUT THE AUTHOR

Alexia Jones Helsley, historian, archivist and educator, is a longtime Columbia resident. *Columbia, South Carolina: A History* is her third book on the history of South Carolina's capital city. The first two were *Lost Columbia: Bygone Images of South Carolina's Capital City* and *Wicked Columbia: Vice & Villainy in the Capital*. Recipient of the Governor's Archives Award, Helsley teaches history at the University of South Carolina–Aiken.